CHEROKEE

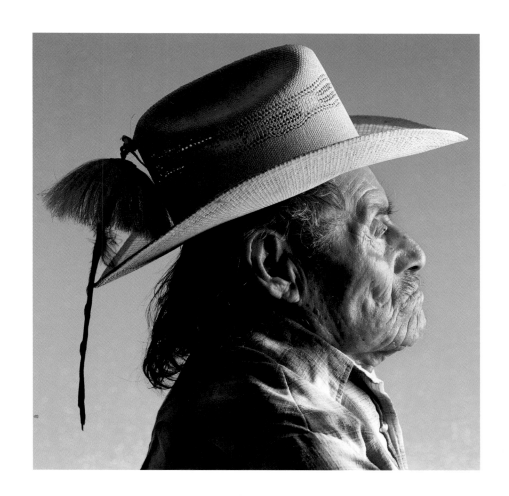

CHEROKEE

PHOTOGRAPHY BY DAVID G. FITZGERALD TEXT BY ROBERT J. CONLEY

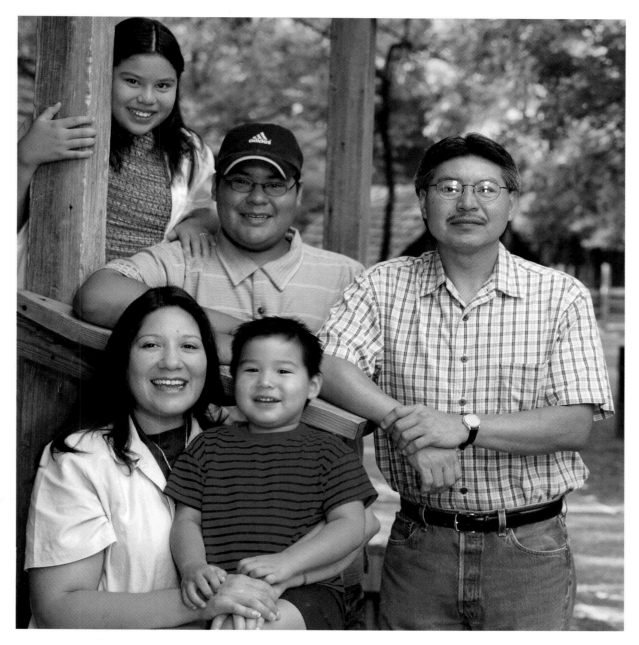

Introduction by PRINCIPAL CHIEF CHADWICK SMITH, Cherokee Nation

GRAPHIC ARTS CENTER PUBLISHING®

To the memory of my friend,
Danny Coffelt. As the Cherokees say,
"Tla ilvhiyu ohni yojiyolilo kilo.
Dodadagohvi ojadisgoi."
("We never give a final handshake to anyone.
We'll see each other again, we say.")

Photos © MMII by David Fitzgerald
Text © MMII by Robert Conley
Book compilation © MMII by
Graphic Arts Center Publishing®
An imprint of Graphic Arts Center Publishing Co.
P.O. Box 10306, Portland, Oregon 97296-0306
503/226-2402; www.gacpc.com

President: Charles M. Hopkins
Associate Publisher: Douglas A. Pfeiffer
Editorial: Timothy W. Frew, Ellen Harkins Wheat,
 Tricia Brown, Jean Andrews, Kathy Matthews,
 Jean Bond-Slaughter
Production: Richard L. Owsiany, Heather Doornink
Design: Elizabeth Watson
Printed by Haagen Printing, Santa Barbara, CA, USA
Bound by Lincoln & Allen Bindery, Portland, OR, USA
First printing

Library of Congress Cataloging-in-Publication Data
Fitzgerald, David, 1935–
 Cherokee / photography by David Fitzgerald ;
essay by Robert J. Conley ; introduction by
Chadwick Smith.
 p. cm.
Includes bibliographical references and index.
 ISBN 1-55868-603-7 (hardbound : alk. paper)
 1. Cherokee Indians. 2. Cherokee Indians—
Pictorial works. I. Conley, Robert J. II. Title.
 E99.C5F58 2002
 975.004'9755—dc21 2002003099

◄◄ THE VANN FAMILY. ALEX AND ELEANOR
VANN AND THEIR CHILDREN, ZACH DANIEL,
CALLIE ELIZABETH, AND SETH ANDREW.
CHEROKEE CULTURES AND LANGUAGE PLAY AN
ACTIVE ROLE IN THE CHILDREN'S EDUCATION.
► MAPLE TREES IN FALL FOLIAGE, CHEROKEE
HERITAGE CENTER, TAHLEQUAH, OKLAHOMA.
►► FALL VIEW OF SMOKY MOUNTAINS FROM
NEWFOUND GAP ROAD, NORTH CAROLINA.
►►► TERRAPIN NECKLACE, MADE BY FRANKIE
SUE GILLIAM. THE STAR REPRESENTS THE SEVEN
CLANS OF THE CHEROKEE.

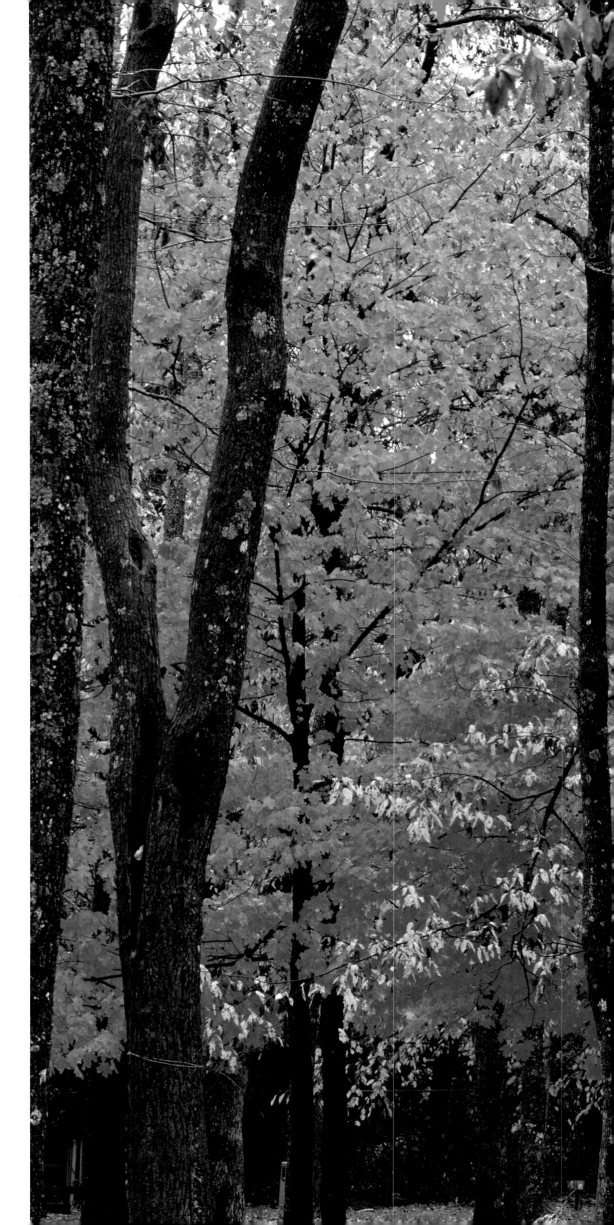

Acknowledgments

To Guy, my father, who I really never knew, but who I think would have treasured this book.

To Mari, one who understands just how crazy this profession is.

To Jay Hannah, who started me on this incredible hunt, and Doug Pfeiffer, my friend of many years and Associate Publisher of Graphic Arts Center Publishing®, who gave me the license to pursue it.

To my young friend Aaron LeMaster, my guide and companion, without whose help and knowledge this book would have been almost impossible to produce.

To Dr. Bob Blackburn; Dan Provo; Dr. Mary Jane Warde; Jeff Briley, my old camping buddy; and all the rest at the Oklahoma Historical Society who were instrumental in making the Smithsonian show, *Cherokee Nation: A Portrait of a People,* a smashing success.

To Mary Ellen Meredith, President of the Cherokee National Historical Society, and Tom Mooney, Curator of Collections, Cherokee Heritage Center, who patiently sat and listened to me try and impress them with my meager knowledge of Cherokee history some years ago when I first started researching for the book, and whose help with the project became invaluable; Sam Watts-Kidd; Thelma Vann Forrest; and Barbara Girty.

To Dorothy Sullivan, who graciously allowed us to use her painting "But This Is My Home"; Mr. Ed Jumper, an expert in the Cherokee Syllabary; Shirley Pettengill, Site Manager at the George Murrell Home in Park Hill, Oklahoma; Rainette Sutton; my good friend David McNeese; Frankie Sue Gilliam and Julie Kiddy, both curators of the Tahlonteeskee Courthouse at Gore, Oklahoma, who would allow me to stop and visit as I was passing through; Russell Townsend, former director of the Sequoyah Birthplace Museum in Vonore, Tennessee; Burnis Argo and the late Kent Ruth, whose book *Oklahoma Historical Tour Guide* was a great tool to find those out-of-the-way places in the Cherokee Nation; Felicia Olaya and Kathy Carter-White, who are both at the Cherokee Tribal Complex in Tahlequah, Oklahoma; and Mr. Jack Baker, President of the Trail of Tears Association, who is not only a great scholar on the Cherokees, but is also an authority on the genealogy of the Cherokees.

To Mr. Ken Blankenship, who took time out from his busy schedule to give me a tour of the Museum of the Cherokee Indian in Cherokee, North Carolina, and allowed me to photograph some of the many treasures within, and James "Bo" Taylor, Archivist, who helped me identify and date some of the artifacts I photographed; Mr. Barry Hipps, General Manager of the Cherokee Historical Association, who graciously gave me permission to photograph the Oconaluftee Village and its people in Cherokee, North Carolina; Aaron Bradley, who assisted me in the Oconaluftee Village; and Mr. James Bird, Eastern Band of the Cherokee Nation, Cultural Resources.

To Principal Chief Wilma Mankiller and her husband, Charlie Soap, who probably could have done a better job of photographing this book than I; Principal Chief Joe and Suzy Byrd; Principal Chief Ross Swimmer; Principal Chief Chad "Corntassel" Smith, whose conversations and suggestions were greatly appreciated; and my good friend Robert Conley, who wrote the text for this book, and his lovely wife, Evelyn. Robert also introduced me to the Breakfast Club, at the Cherokee Tribal Restaurant, whose company included Orvel Baldridge, David Scott, and an extremely talented artist, Murv Jacob; thanks for all of those hilarious memories.

To all of the Cherokees who allowed me to take their portraits, thank you.

Last, but not least, to my editor, Ellen Wheat, who several years ago joined the hunt and came to Oklahoma to have a Cherokee experience during the Cherokee National Holiday. She has kept me on the straight and narrow ever since.

—D. F.

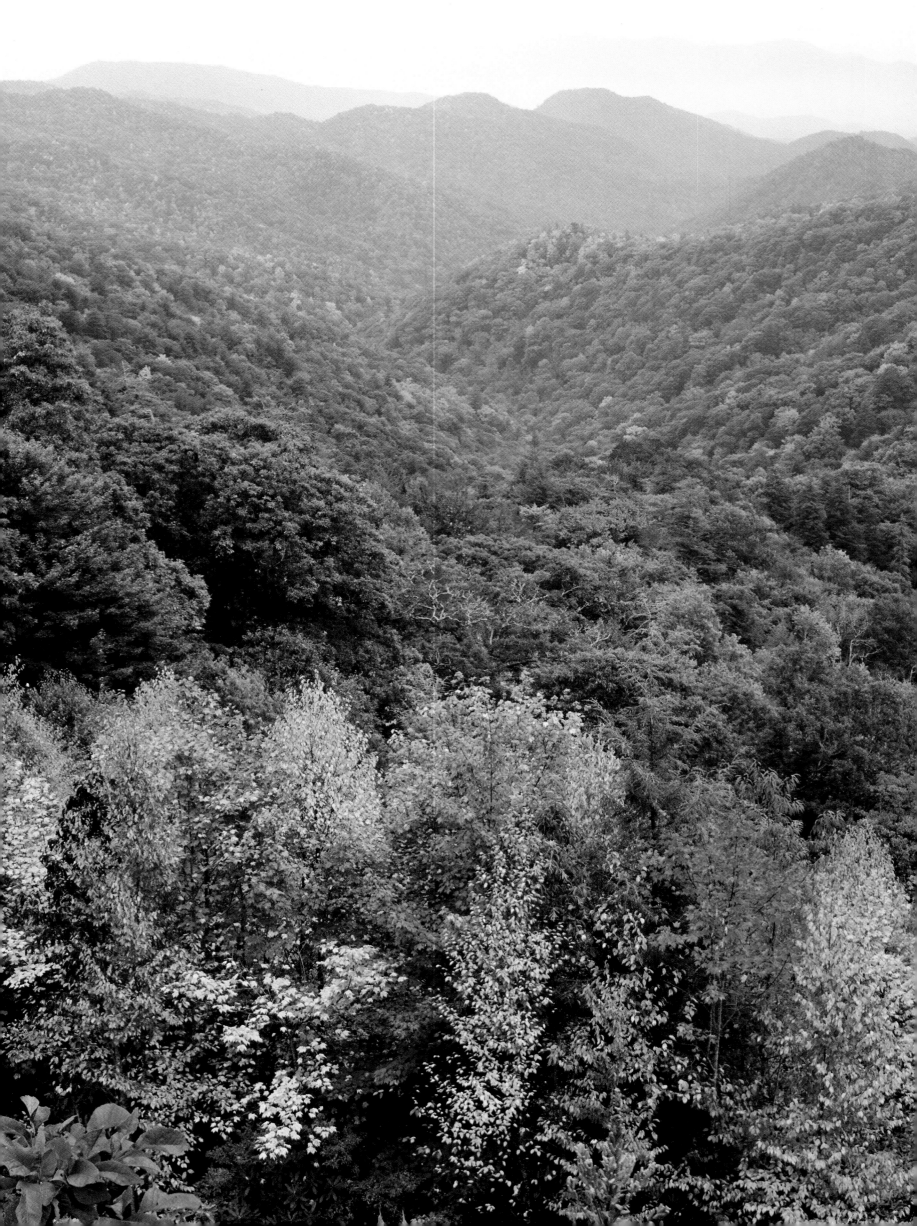

Contents

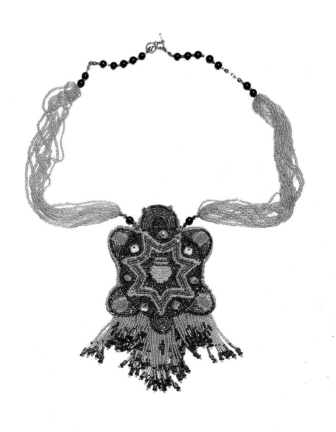

WATER ROUTE
NORTHERN ROUTE
HILDEBRAND'S ROUTE
BENGE'S ROUTE
BELL'S ROUTE
TAYLOR'S ROUTE

MILES
0 25 50 75

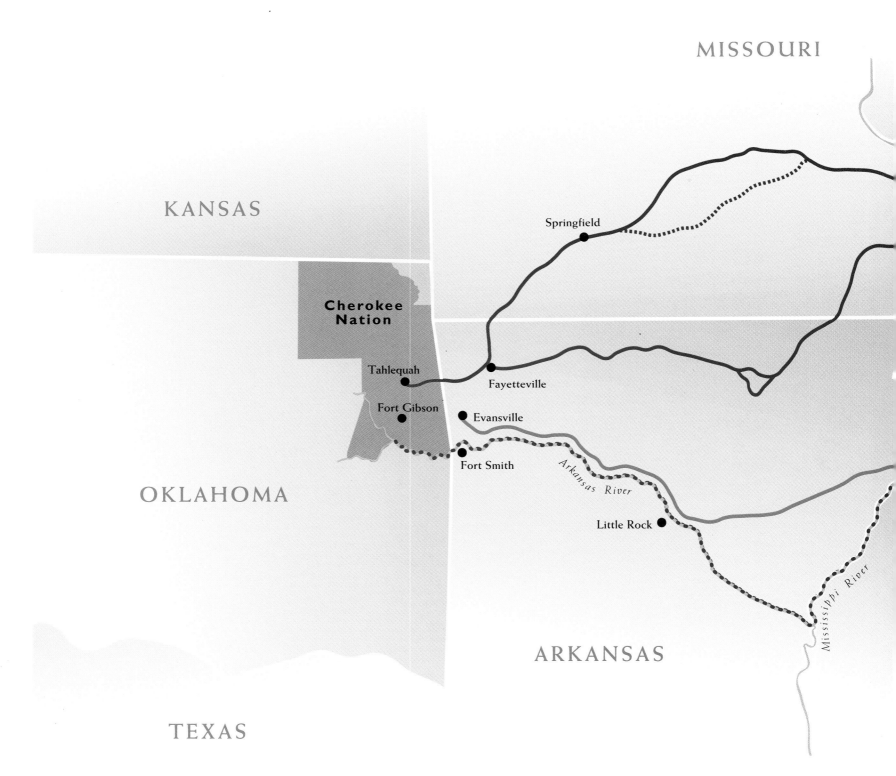

MISSOURI

KANSAS

Springfield

Cherokee
Nation

Tahlequah

Fayetteville

Fort Gibson

Evansville

Fort Smith

OKLAHOMA

Arkansas River

Little Rock

Mississippi River

ARKANSAS

TEXAS

TRAIL OF TEARS

AREA OF MAP

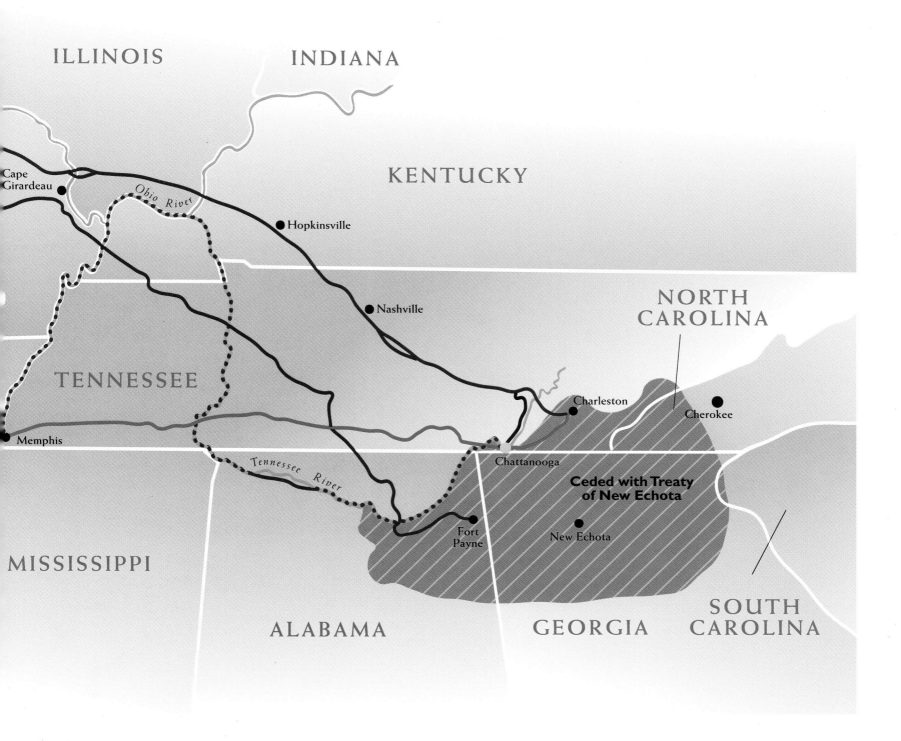

ILLINOIS

INDIANA

KENTUCKY

Cape
Girardeau

Ohio River

● Hopkinsville

NORTH
CAROLINA

● Nashville

TENNESSEE

Charleston

● Cherokee

● Memphis

Tennessee River

Chattanooga

**Ceded with Treaty
of New Echota**

MISSISSIPPI

Fort
Payne

● New Echota

ALABAMA

GEORGIA

SOUTH
CAROLINA

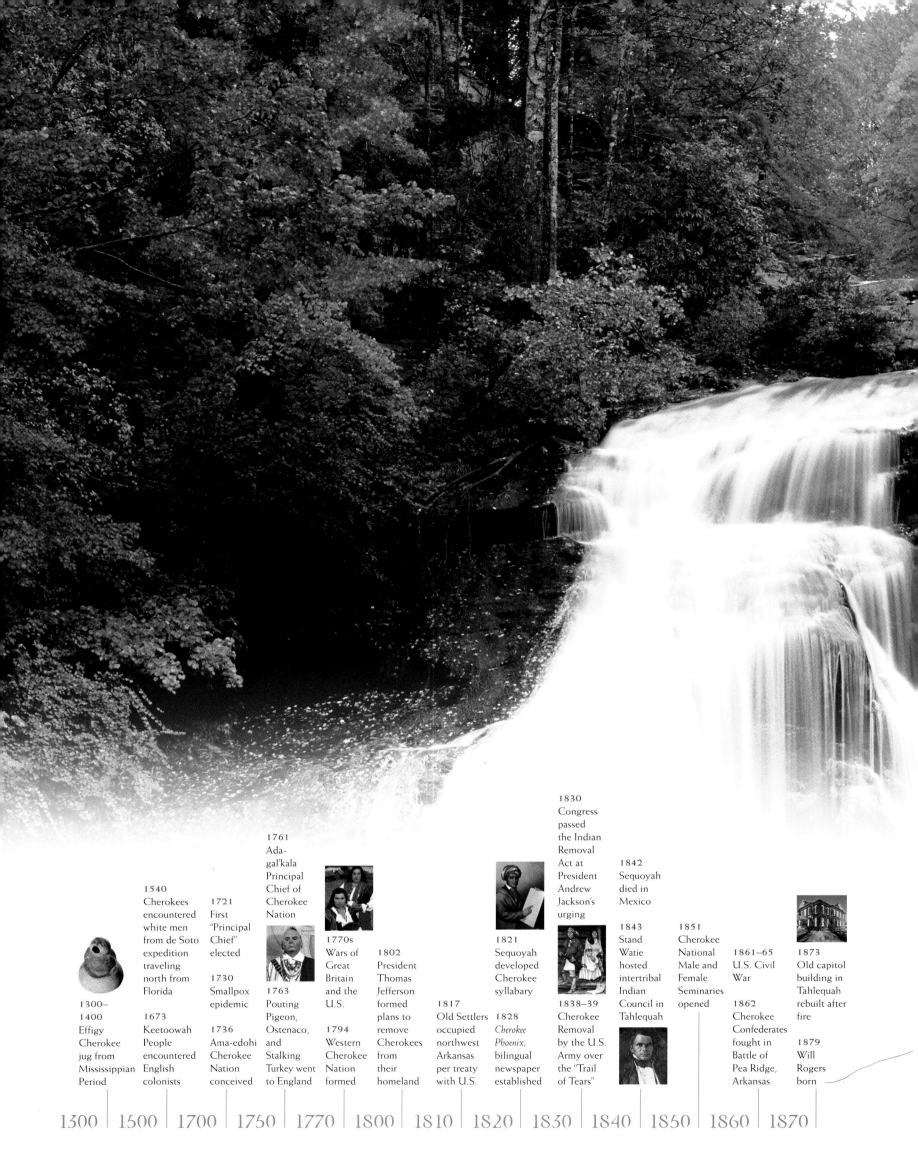

1300–1400
Effigy Cherokee jug from Mississippian Period

1540
Cherokees encountered white men from de Soto expedition traveling north from Florida

1673
Keetoowah People encountered English colonists

1721
First "Principal Chief" elected

1730
Smallpox epidemic

1736
Ama-edohi Cherokee Nation conceived

1761
Ada-gal'kala Principal Chief of Cherokee Nation

1763
Pouting Pigeon, Ostenaco, and Stalking Turkey went to England

1770s
Wars of Great Britain and the U.S.

1794
Western Cherokee Nation formed

1802
President Thomas Jefferson formed plans to remove Cherokees from their homeland

1817
Old Settlers occupied northwest Arkansas per treaty with U.S.

1821
Sequoyah developed Cherokee syllabary

1828
Cherokee Phoenix, bilingual newspaper established

1830
Congress passed the Indian Removal Act at President Andrew Jackson's urging

1838–39
Cherokee Removal by the U.S. Army over the "Trail of Tears"

1842
Sequoyah died in Mexico

1843
Stand Watie hosted intertribal Indian Council in Tahlequah

1851
Cherokee National Male and Female Seminaries opened

1861–65
U.S. Civil War

1862
Cherokee Confederates fought in Battle of Pea Ridge, Arkansas

1873
Old capitol building in Tahlequah rebuilt after fire

1879
Will Rogers born

1300 1500 1700 1750 1770 1800 1810 1820 1830 1840 1850 1860 1870

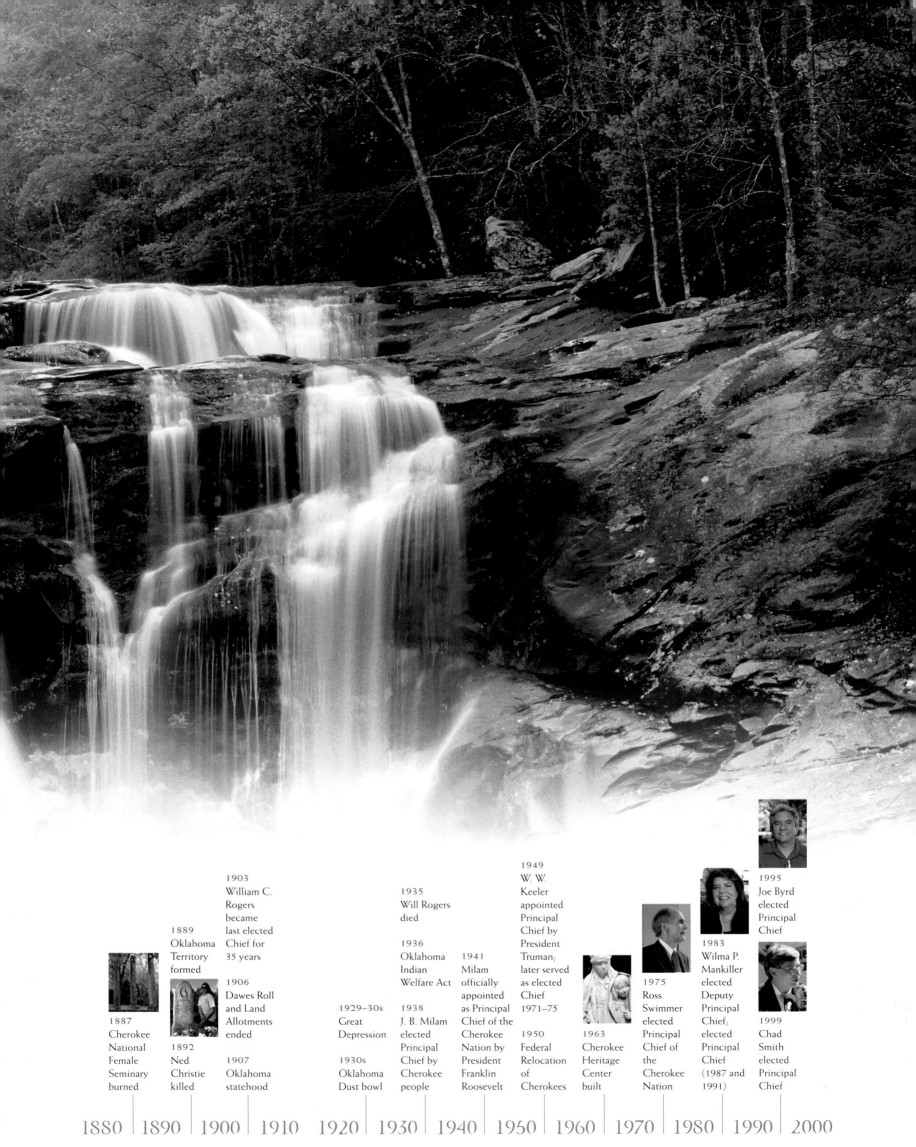

1887
Cherokee
National
Female
Seminary
burned

1889
Oklahoma
Territory
formed

1892
Ned
Christie
killed

1903
William C.
Rogers
became
last elected
Chief for
35 years

1906
Dawes Roll
and Land
Allotments
ended

1907
Oklahoma
statehood

1929–30s
Great
Depression

1930s
Oklahoma
Dust bowl

1935
Will Rogers
died

1936
Oklahoma
Indian
Welfare Act

1938
J. B. Milam
elected
Principal
Chief by
Cherokee
people

1941
Milam
officially
appointed
as Principal
Chief of the
Cherokee
Nation by
President
Franklin
Roosevelt

1949
W. W.
Keeler
appointed
Principal
Chief by
President
Truman;
later served
as elected
Chief
1971–75

1950
Federal
Relocation
of
Cherokees

1963
Cherokee
Heritage
Center
built

1975
Ross
Swimmer
elected
Principal
Chief of
the
Cherokee
Nation

1983
Wilma P.
Mankiller
elected
Deputy
Principal
Chief;
elected
Principal
Chief
(1987 and
1991.)

1995
Joe Byrd
elected
Principal
Chief

1999
Chad
Smith
elected
Principal
Chief

1880 | 1890 | 1900 | 1910 | 1920 | 1930 | 1940 | 1950 | 1960 | 1970 | 1980 | 1990 | 2000

11

INTRODUCTION

by PRINCIPAL CHIEF CHADWICK SMITH, *Cherokee Nation*

The Cherokee Nation is a resilient Indian republic. Its history and culture reveal a legacy that defines the Cherokee peoples' lives, family, and community. Our legacy comes from our parents and ancestors, from time immemorial. The Cherokee legacy is that we are a people who face adversity, survive, adapt, prosper, and excel.

Our legacy has been demonstrated in many episodes of our history. In the 1730s, we lost half of our population to smallpox because of commercial trade with England. In the 1770s, we faced the genocidal wars of Great Britain and the United States designed to wipe us from the face of this continent. In the 1830s, we faced political and legal battles to save our homeland and existence. That episode resulted in the "Removal" of our people along the "Trail of Tears" in 1838 through 1839. We faced those adversities, and survived and adapted.

Then followed the Cherokee civil war, the American Civil War, the land allotment of the 1890s, the federal effort to dissolve our government in the 1900s. We suffered in the Great Depression and Oklahoma Dust Bowl, when half our population left Oklahoma for Texas and California. In the 1950s and '60s, the federal "Relocation" program further dispersed our people. In 1975, a federal judge found that the Bureau of Indian Affairs had practiced a policy of "bureaucratic imperialism" against the Cherokee Nation since the turn of the century. And that year, the Cherokee Nation increased efforts to revive the nation.

The Cherokee legacy was paid for with thousands of lives and millions of acres. But it comes with a duty, responsibility, and obligation. We acknowledge that there can be no greater honor than to carry on this legacy. Every decision we make today must be a wise one so that one hundred years from now our grandchildren and great-grandchildren may come to the spot in front of our capitol building and know that they have a strong tribal government, enjoy economic self-reliance, and share an enriching culture.

Few Americans understand that one hundred years ago, the Cherokee Nation had had a sophisticated society, governmental infrastructure, and an educational system since 1844. The Cherokee Nation built the first public building in Indian Territory, which is now Oklahoma—the Cherokee Nation Supreme Court. We went on to build a capitol building, nine district courthouses, two junior colleges, including the first institution of higher education for women west of the Mississippi, 150 day schools, hospitals, and asylums for orphans, the mentally ill, and the aged, and a penitentiary. Cherokees were 90 percent literate in their own written language developed by Sequoyah in 1821. We had a bilingual newspaper in 1828. In the fifty years after the infamous Trail of Tears, the Cherokees demonstrated clearly the legacy of facing adversity and then surviving, adapting, prospering, and excelling.

In 1887, U.S. Sen. Henry Dawes reported that in the Cherokee Nation, there was not one pauper, every family had a home of its own, and the Cherokee government owed not a dollar. But he went on to say that the fallacy of the Cherokee Nation's system was apparent in the fact that there was no "selfishness," which is at the bottom of civilization, and that there was no incentive to make one's own home any better than his neighbor's.

Federal policy was not based on what was good for the Indians but what was good for the Americans. In 1901, the Cherokees acquired American citizenship in addition to their own Cherokee Nation citizenship. The U.S. government proceeded to take tribal title to Cherokee lands and attempted to extinguish the government of the Cherokee Nation. By 1920 the American policy to get our lands was so successful that we had lost 90 percent of our land.

Today, one hundred years later, we must first ask these questions in order to fulfill and carry forward the great Cherokee legacy.

Where will we be as a people five, ten, fifty, or one hundred years from now? Do we talk only of ancestors or do we plan for our descendants? Do we talk about our full-blood ancestors or do we admire our Indian grandchildren? Do we live in the past or do we focus on the future? Is being Cherokee a novelty or a way of life? Is being Cherokee a heritage or a future?

The lessons from our ancestors have given us a strategy for survival. Our history tells us that the federal government changes policy toward Indians every twenty to forty years. That means in the next hundred years, we can expect the United States to abandon us two or three more times. Are we prepared? Do we have strong communities and families? Are we driven by our culture of *ga du gi* or are we becoming weaker by consumerism and entitlement mentalities?

There was a poster on the construction wall of the new Museum of the American Indian on the Mall in Washington, D.C. It contained an 1899 photograph of a seven-year-old Cherokee girl in a cutoff cotton print dress, barefoot, carrying water in a molasses bucket over a bridge in front of the Female Seminary in Tahlequah, the capital of the Cherokee Nation. The girl has the brightest smile. She serves individually and collectively as a symbol of the Cherokee Nation that survived the horrific events of the prior two centuries. But even more impressive on the cover of the Cherokee Nation Holiday brochure in 2000 was a seven-year-old girl who looked much like the girl from a hundred years prior. The Cherokee girl in 2000 was a symbol that the Cherokee Nation was able to survive another one hundred years. Our challenge and charge is to make wise decisions so that one hundred years from now, there will be similar seven-year-old Cherokee girls found in our homes, communities, public buildings, and schools.

The ultimate question is whether we will survive and continue this legacy. The answer is simple and clear. Yes.

The photographs in this book are evidence of the tenacious and indomitable Cherokee spirit, which is seen in the determination, character, tenderness, and genuineness of these Cherokee faces. David Fitzgerald is to be commended for his effort to capture this spirit from every corner of the Cherokee world.

TAHLEQUAH

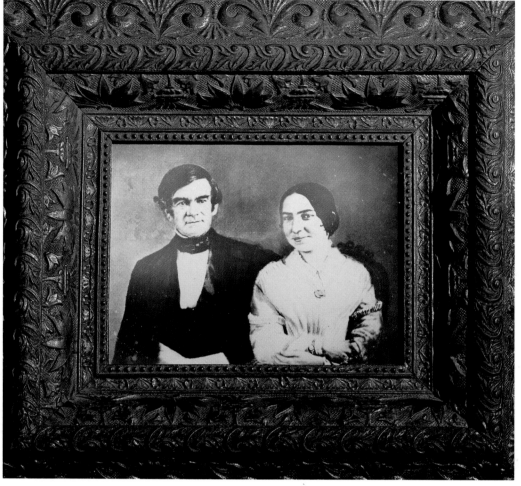

Linking back. That, I think, is the secret of the Indian's
attachment to the land, really of any human being's concern with place.
We have reverence for a particular place because of our knowledge of or sense of
what was there before, and our connection to the past gives us a reason for being,
a sense of belonging, and a feeling for, if not real knowledge of, our origins.
It defines us. It tells us who we are. Madness is, I think, a broken link.
The chain that links us back holds the anchor for our sanity.

Linking back. Joseph Campbell said in a television interview once that the word *religion* means "linking back." That's what I do constantly in this Cherokee country, now called northeast Oklahoma, of which Tahlequah is the center—*Ayehli.*

Linking back. I live in Tahlequah, the capital city of the Cherokee Nation. Not even paved roads (often in need of repair), new buildings, and automobile traffic can interfere with the linking-back process. I can drive down Muskogee Avenue, the main street in Tahlequah, past the bars and the banks, stopping at the traffic lights, smelling the exhaust fumes from the heavy traffic, reading the sometimes gaudy signs of new businesses, pizza parlors, fast-food restaurants, car lots, liquor stores, auto parts stores, the new Wal-Mart Super Center, and not even these distractions can drive from my

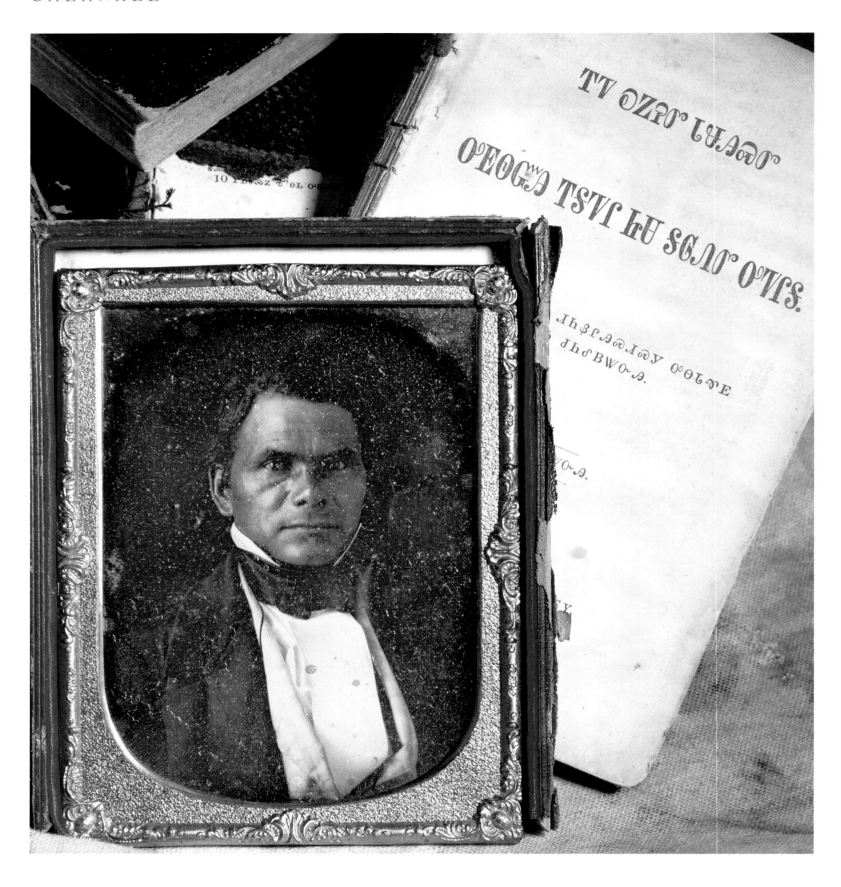

▲ Photograph on glass believed to be of Gen. Stand Watie. The ambrotype was a popular technique for portraits during the period 1855–65. It is shown with a New Testament Bible in Cherokee printed in 1850 by the American Bible Society. *Collection of the Cherokee Heritage Center.*

mind the constant realization that I am on a street where Principal Chief John Ross rode in his carriage, where General Stand Watie led his Cherokee Confederate troops, where hundreds of Indians thronged when the Cherokee Nation hosted the great intertribal Indian Council in 1843.

Linking back. That, I think, is the secret of the Indian's attachment to the land, really of any human being's concern with place. We have reverence for a particular place because of our knowledge of or sense of what was there before, and our connection to the past gives us a reason for being, a sense of belonging, and a feeling

for, if not real knowledge of, our origins. It defines us. It tells us who we are. Madness is, I think, a broken link. The chain that links us back holds the anchor for our sanity.

I live in the Cherokee Nation. I do not consider that I live in Oklahoma. Of course, I have to deal with the reality of Oklahoma. It came in on top of the Cherokee Nation and imposed its own laws, and I have accepted that reality. I have accepted it, and I live with it, because I want to live in Tahlequah, in the Cherokee Nation.

One of the many things that I love about living in Tahlequah is that I am constantly surrounded by reminders of the history that I am so much involved with. When I drive to town to check my mail, I go along Water Street, the first road leading from the capitol, where Chief John Ross and others went to work, to Park Hill, where Ross and some of the others had their homes. I think about Ross in his buggy making his way to the government offices on the square. If I drive all the way downtown, I will see the old capitol building, rebuilt after a fire in 1873. Ned Christie and other council members about whom I have read and written were in that building, and I thrill when I think that the Cherokee Nation, having lost all of its government buildings at Oklahoma statehood in 1907, owns the building once again.

From the south side of the capitol square, I can look across the street at the old Cherokee National Supreme Court Building, the first two-story brick structure built in what is now the state of Oklahoma. I can go one block farther south and see the old Cherokee National Prison. All of these historic buildings are once again Cherokee Nation property. A few blocks north, on Muskogee Avenue, the last of the old buildings still stands. What Northeastern State University now calls Seminary Hall is the old Cherokee National Female Seminary. It's not the original Female Seminary, which was

Continued on page 21

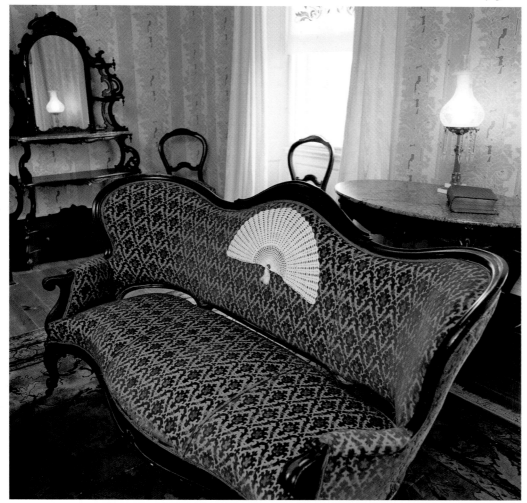

▲ BIBLE ON DISPLAY IN THE MURRELL HOME PARLOR, PARK HILL, OKLAHOMA. THE BIBLE BELONGED TO MARY STAPLER, AND IS DATED ON THE DAY SHE WAS MARRIED TO PRINCIPAL CHIEF JOHN ROSS IN SEPTEMBER 1844. *Collection of the Cherokee Heritage Center.*

◄ FURNISHINGS IN THE PARLOR OF THE MURRELL HOME, PARK HILL, OKLAHOMA, THAT BELONGED TO PRINCIPAL CHIEF JOHN ROSS AND HIS WIFE. *Collection of the Cherokee Heritage Center.*

THE KEETOOWAH MOUND IS THOUGHT TO BE THE SITE OF THE ANCIENT CHEROKEE VILLAGE, KEETOOWAH, THE "MOTHER TOWN," WHERE ALL CHEROKEES ORIGINATED. THE CHEROKEE

Keetoowah

Keetoowah is the name of an ancient Cherokee town in the eastern homeland of the Cherokees, said to be the "mother town" of the people. It's the town, according to tradition, where all Cherokees originated. When the population grew too large for the town, people moved out and built a new town. Therefore, as a friend of mine said while we were visiting the site of the sacred town, "This is where we all came from."

Like nearly all of the old Cherokee country, the site of Keetoowah was lost to the Cherokees at the time of Removal. Its ownership, however, has in recent years been returned to Cherokee hands. The Eastern Band of Cherokees purchased it from private

KEETOOWAH COUNCIL HOUSE ONCE STOOD NEAR THIS MOUND. THE LAND IS NOW PART OF THE HOLDINGS OF THE EASTERN BAND OF THE CHEROKEE.

owners who had been farming it for years. Remarkably, the original mound that was at the center of the town is still visible.

Cherokees sometimes refer to themselves as *Ani-Kituwagi*, or Keetoowah People. The word *Keetoowah* (spelled variously as Kituwah or Giduwa) cannot with certainty be translated, but it is much used. The traditionalist Cherokee full-blood society is called the Keetoowah Society, and when a group of full-blood Cherokees took advantage of the 1936 Oklahoma Indian General Welfare Act to organize in effect a new federally recognized Indian tribe, they chose to call it the United Keetoowah Band of Cherokee Indians in Oklahoma. Like the Cherokee Nation, the UKB is headquartered in Tahlequah, Oklahoma.

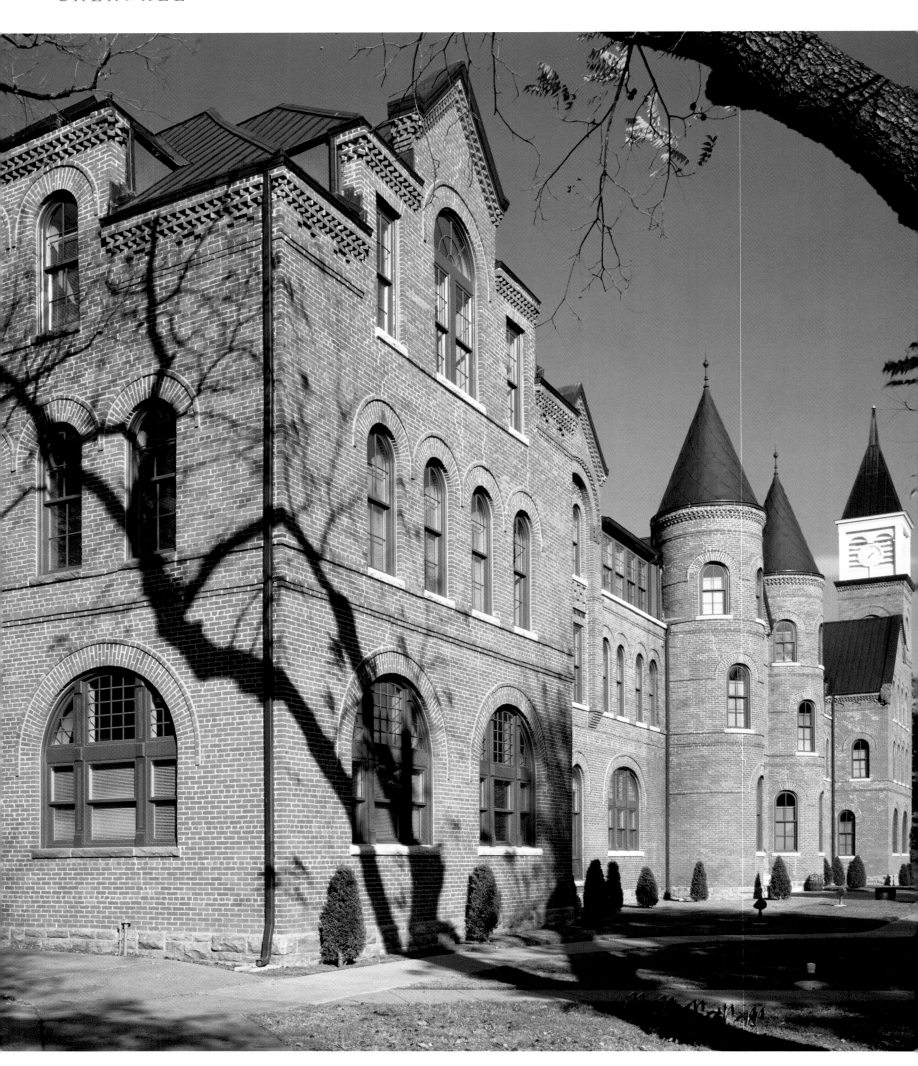

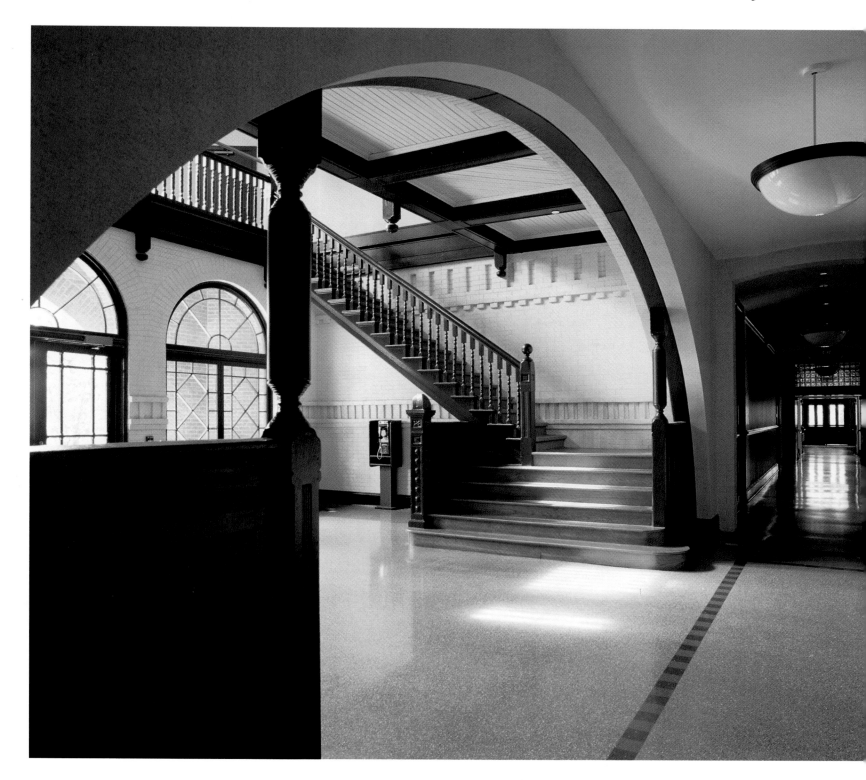

located south of town on land now occupied by the Cherokee Heritage Center. When it burned in 1887, it was rebuilt north of town. My grandmother went to school there.

In 1890, when my grandmother was born, there was no state of Oklahoma. She was born a citizen of the Cherokee Nation. When Oklahoma became a state in 1907, she became, by U.S. law, a citizen of the new state of Oklahoma and of the United States. The Cherokee Nation was effectively dismantled. Its capitol building was taken over by the new Cherokee County and used as a county courthouse. Its national prison was taken over by the county for a county jail. Its Cherokee National Female Seminary was taken by the state and became a state normal school that has since developed into Northeastern State University. Its newspaper, the *Cherokee Phoenix*, was purchased for a song by someone in Muskogee to become the *Muskogee Phoenix*, still published to this day and still with that same name.

◄ SEMINARY HALL, 1887–89. THE HALL WAS CONSTRUCTED TO REPLACE THE CHEROKEE NATIONAL FEMALE SEMINARY, WHICH BURNED IN 1887. THE BUILDING IS STILL IN USE AT NORTHEASTERN STATE UNIVERSITY, TAHLEQUAH, OKLAHOMA.
▲ INTERIOR ENTRANCE OF SEMINARY HALL, 1889.

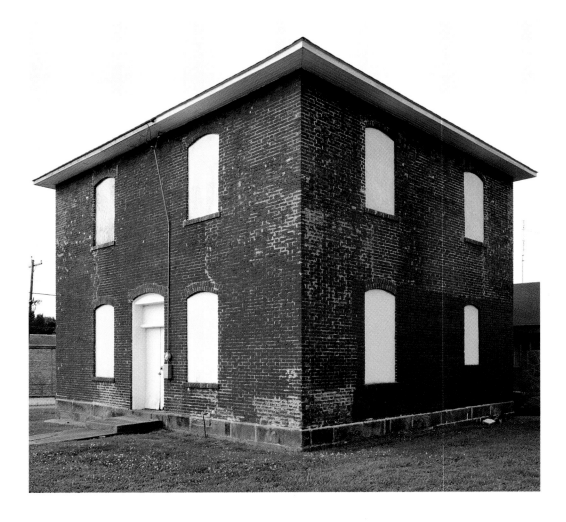

▲ THE OLD BRICK CHEROKEE NATIONAL SUPREME COURT, 1844. THIS BUILDING STILL SITS ACROSS FROM CAPITOL SQUARE IN DOWNTOWN TAHLEQUAH, OKLAHOMA.

► CHEROKEE HOUSE FROM THE 1750s. TRADITIONAL CHEROKEE LOG HOUSES WERE SOLIDLY BUILT, WITH SQUARED DOOR JAMBS AND SQUARED LOGS. THERE WAS ONLY A DOOR AND NO WINDOWS FOR LIGHT. THEY HAD WELL-CONSTRUCTED STONE FIREPLACES AND MOST HAD PORCHES. IT IS THOUGHT THAT THE EXTERIORS WERE DECORATED WITH ANIMAL SKINS, GOURDS, AND VARIOUS PLANTS. OCONALUFTEE INDIAN VILLAGE, CHEROKEE, NORTH CAROLINA.

My father was born in 1920, deprived of citizenship in an independent Cherokee Nation by a short thirteen years, and I myself was born only thirty-three years after the onset of statehood. I feel that loss keenly and every day. That is another result of living in Tahlequah: living with the history on a daily basis, being constantly aware of the things that have taken place over the years, realizing daily that the past is not that long ago, that in fact it is still with us and will always be with us.

The United States of America signed thirty-three treaties with the Cherokee Nation. In each of them, it took land away from the Cherokees, and in each, it promised that it would not come back for more. In each it pledged perpetual peace and friendship. In some, it forbade American citizens to trespass and squat on Cherokee lands and said that if any did so, the Cherokee Nation could deal with them as it pleased. Yet white Americans did move onto Cherokee land, and the government did nothing about it. When the Cherokees attempted to do something about it, the U.S. government moved to protect its citizens and the interests of its citizens, and following the conflict thus generated, a new treaty would be signed, and more land would be wrenched away from the Cherokees. It is a pattern almost as old as contact between the Cherokees and the English colonists.

When I first visited the old Cherokee country in South Carolina, I was awestruck by its beauty, but I was also saddened and angered at the theft of all that from my ancestors. My feelings were intensified when I found the name of one of my own ancestors on local maps. I made a second trip to the old Cherokee country, this time to North Carolina, where I met for the first time many Eastern Cherokees, descendants of those hardy few who managed to avoid the disastrous Cherokee Removal of 1838–39 known as the Trail of Tears. They welcomed me home. One gracious lady said, "My

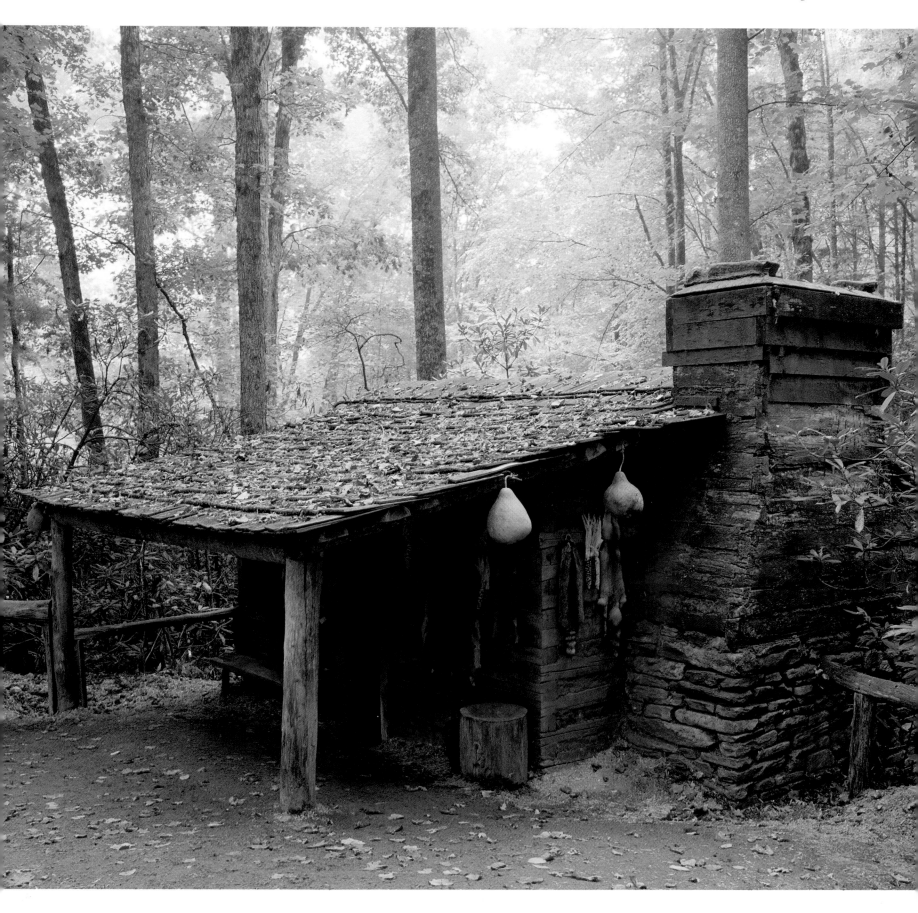

father always told us, 'When anyone from Oklahoma comes out here, welcome them into your home. They're your relatives.' " I knew that those people were living where we all should live, and I realized that more fully when my friend Tom Belt took me to visit the site of the ancient town of Keetoowah, the mother town, the town from which all other Cherokee towns developed, the town where we all come from. It was perhaps the most profound experience of my life.

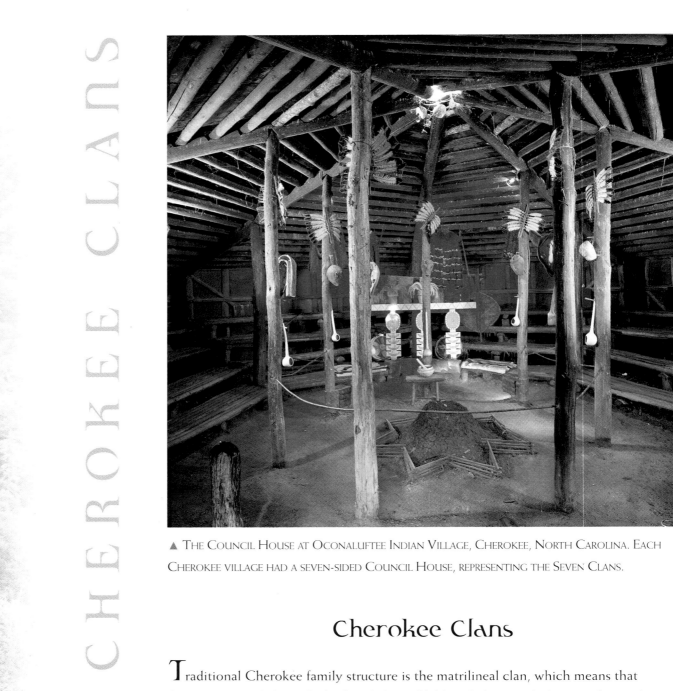

▲ The Council House at Oconaluftee Indian Village, Cherokee, North Carolina. Each Cherokee village had a seven-sided Council House, representing the Seven Clans.

Cherokee Clans

Traditional Cherokee family structure is the matrilineal clan, which means that descent is traced through the female line. Children belong with their mother and their mother's clan. When a man marries, he moves into a house owned by his wife. If a woman has sisters, say four, then her children, for all practical purposes, have five mothers. The training and discipline of boys is the responsibility of the boy's mother's brothers, especially the oldest. The father is almost irrelevant. He is not even really a member of the family. If the matrilineal clan is the family, then the father's family is his mother's clan, and his main child-rearing responsibility is the children of his sister.

The people who in a European-style family would be called first cousins are, in a matrilineal clan, called brothers and sisters, but only on the mother's side. This fact has undoubtedly caused some confusion among historians. For example, some historians tell us that Dragging Canoe and Nancy Ward were first cousins. Others say they were brother and sister. If they were both members of the same clan, then it is likely that they were first cousins who called each other brother and sister.

The same seven clans were represented in all of the historic Cherokee towns, so if a Cherokee were to travel across the entire distance of the old Cherokee country and visit a town he had never seen before, he would find relatives there—clan brothers and sisters, aunts and uncles. He would be accepted as a member of the family.

It has been said that the Cherokees once had fourteen clans, but that in long migrations over the ages, seven of them were lost. As far back as we know historically, there have been seven Cherokee clans:

Wolf Clan *ani-waya*
Deer Clan *ani-kawi* (or *ani-awi*)
Long Hair Clan *ani-gelohi*
Bird Clan *ani-tsi-squa* (or *ani-jisqua*)
Wild Potato Clan *ani-godagawi*
Blue Clan *ani-sahoni*
Paint Clan *ani-wodi*

According to Hastings Shade, current Deputy Principal Chief of the Cherokee Nation, the Wolf Clan is the largest of the clans. War chiefs usually came from the Wolf Clan, and only members of the Wolf Clan were allowed to kill a wolf. The Deer Clan members were keepers of the deer and were fast runners and good hunters. The Long Hair Clan is also known as the Wind Clan, Hair Hanging Down Clan, or the Twister Clan. They wore their hair in a distinctive way. The peace chief came from the Long Hair Clan. The Bird Clan were keepers of the birds and were messengers. The Blue Clan is also known as the Panther Clan or the Wildcat Clan and produced medicine people for the children. Sorcerers and other medicine people came from the Paint Clan. The Wild Potato Clan, also called the Bear Clan, Raccoon Clan, or Blind Savannah Clan, were the keepers of the land.

Clans had functions that went well beyond family structure and the specific clan roles mentioned above. Many things that in European or contemporary American society are considered matters for the state were in the old days among Cherokees considered clan matters. For instance, if a member of the Bird Clan offended a member of the Wolf Clan, it was necessary for the Wolf Clan to retaliate against the Bird Clan. Even murder was not a crime against the state, but a crime against the victim's clan.

The matrilineal clan provided a safe and secure environment for women and children, probably the best ever devised. Because a man lived in his wife's house, surrounded by her clan brothers, uncles, and nephews, he would not dare abuse her, even if the idea entered his head. In fact, the opposite may have been at least sometimes true. Alexander Longe, an early European observer of Cherokee life, wrote: "A woman will take a stick and beat her husband from his head to his heels, and when he can stand it no longer, he will roll over and let her beat the other side." And divorce was easy among the Cherokees. When it happened, the children stayed with their mother.

The clan system began to be undermined early in Cherokee history when the first European traders married Cherokee wives. The white men were used to the notion of being head of the household and they would not give it up, nor could they accept the notion of tracing descent through the female line. Their children were given their European surnames. Slowly the clan system gave way to the European style bilateral family with a male head of household.

Most Cherokees today do not know their clan affiliation. Some do, but even then, the clan no longer functions as it did long ago, although some vestiges of clan lifestyles can still be seen. And today, the seven-pointed star at the center of the Cherokee Nation flag symbolizes the seven Cherokee clans.

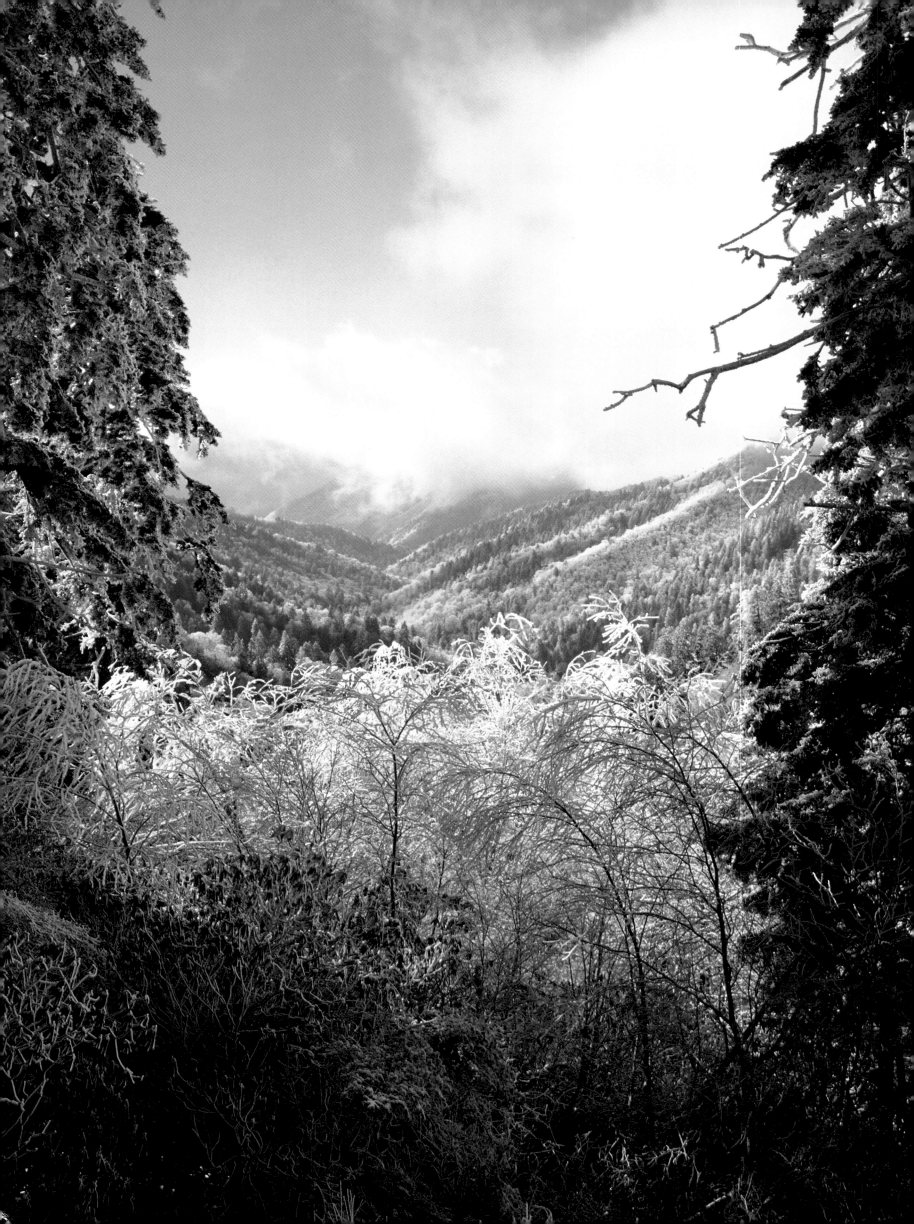

EARLY HISTORY

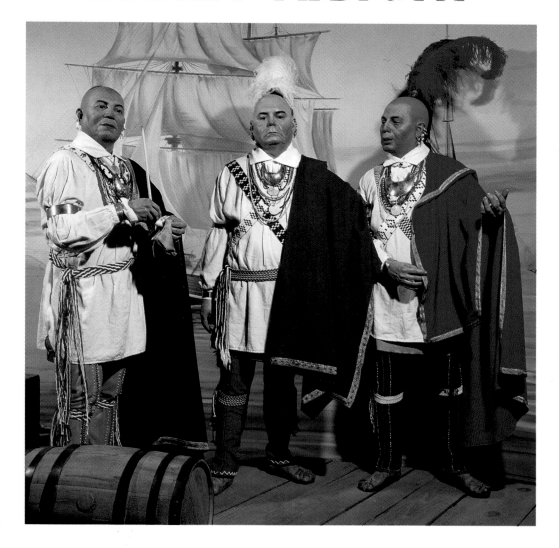

◄◄ A WINTER SNOWFALL IN THE GREAT
SMOKY MOUNTAINS, NORTH CAROLINA–
TENNESSEE, WHICH WERE PART OF THE
CHEROKEES' TRADITIONAL HOMELAND.
◄ DISPLAY OF MANNEQUINS OF CHEROKEES
POUTING PIGEON, OSTENACO, AND STALKING
TURKEY, WHO, AFTER SEEING A PORTRAIT OF
KING GEORGE, WENT TO ENGLAND IN 1763
TO MEET HIM. THEY CONSIDERED KING
GEORGE A GREAT WARRIOR. *Museum of the
Cherokee, Cherokee, North Carolina.*
▼ RARE CHEROKEE POTTERY EFFIGY JUG,
MAYBE AS OLD AS THE MISSISSIPPIAN PERIOD
(1300–1400). THE POT WAS FOUND IN THE
SOUTHEAST UNITED STATES.
Museum of the Cherokee.

*We Cherokees came from Keetoowah, an ancient
Cherokee town. In those early days the People called themselves
Ani-Kituwagi, meaning People from Keetoowah, or Ani-yunwi-ya,
the Real People. . . . By the time the first English colonists encountered the
Keetoowah People, in 1673, seeking trade, the Keetoowah People, soon to be
known as Cherokees, were living in approximately two hundred towns.*

Like all human beings, I believe, we need to know our history and where we
came from. We Cherokees came from Keetoowah, an ancient Cherokee town. In those
early days the People called themselves *Ani-Kituwagi,* meaning Keetoowah People,
or *Ani-yunwi-ya,* the Real People. As the population grew, some people moved out of
Keetoowah and built new towns. By the time the first English colonists encountered
the Keetoowah People, in 1673, seeking trade, the Keetoowah People, soon to be
known as Cherokees, were living in approximately two hundred towns scattered
throughout all or parts of the present states of North Carolina, South Carolina,
Kentucky, Tennessee, Virginia, West Virginia, Georgia, and Alabama. Much of that
Cherokee land was in the rugged and beautiful Appalachian Mountains.

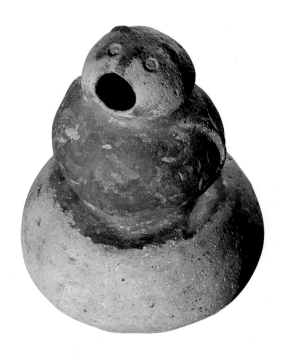

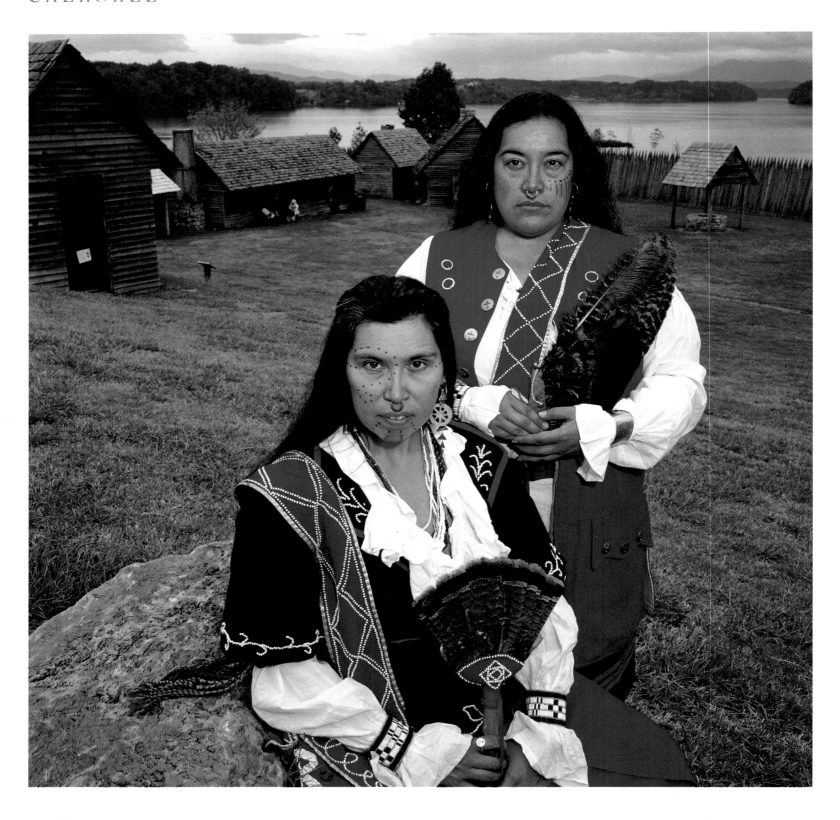

▲ SISTERS VICKIE SMITH AND SHIRLEY
KENNY REENACT THE CHEROKEES OF THE
FRENCH AND INDIAN WAR PERIOD, 1750s.
THEY ARE AT THE SITE OF THE BRITISH FORT
LOUDON, BUILT IN 1756, WHICH STANDS
AT THE CONFLUENCE OF THE LITTLE
TENNESSEE AND TELLICO RIVERS.

In those days, Cherokees were divided geographically and linguistically into three groups, usually called the Upper Towns, Lower Towns, and Middle Towns, with each group speaking a different dialect of the language.

The Cherokee language is an Iroquoian language, related to Mohawk, Seneca, Cayuga, Oneida, Onondaga, and Tuscarora. The Cherokees did not live near those other, northern, Iroquoian people, though. Their nearest neighbors were mostly Muskogean-speaking peoples, member tribes of the large and powerful Muskogee, or Creek, Confederacy.

Each of the two hundred or so Cherokee towns scattered over that vast area of land was autonomous, having a government consisting of a war chief and a peace chief. Each chief had his advisors. But the powers of the chiefs were minimal. They were only

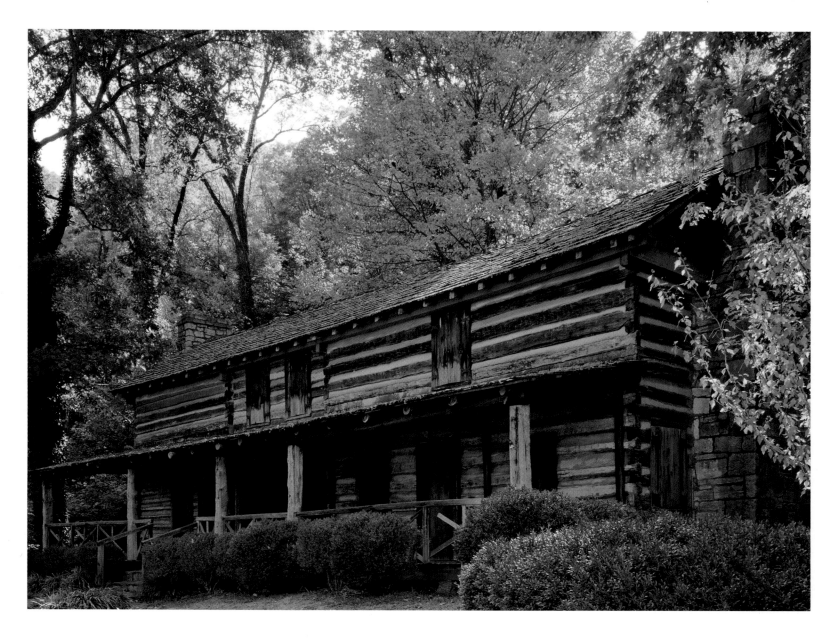

the powers given to them by the People. When a serious decision had to be made, the entire town met in a large council house to discuss the issue. And, though somewhat behind the scenes, the women were important in the political process. Early Europeans complained that the Cherokee men seemed unable to make up their minds. Following negotiations, the Cherokees would ask for another meeting a few days later. What the Europeans failed to realize was that the Cherokee men had to go home to talk to the women before they could render their decisions. When the Europeans at last realized what was going on, they scoffed at the Cherokees for having "a petticoat government." Early European observer Alexander Longe said, "Among the Cherokees, the women rules [sic] the roost."

There is a reason the towns were autonomous. It's explained in an old tale. There was a time long ago when the Cherokees had a powerful priesthood, called the *Ani-Kutani.* (The name can no longer be translated.) The priests had become all powerful and tyrannical. One day a Cherokee hunter came home following an extended hunting trip, and he could not find his wife. He asked his friends and neighbors if they knew where she had gone, and one of them finally told him, "While you were gone, the priests came and took her away." The hunter gathered some of his friends around him, and they discussed what to do about the haughty and despotic priests. They all agreed that the priests had indeed gone too far, and the young men rose up against them and

▲ JOHN ROSS HOUSE, ROSSVILLE, GEORGIA, BUILT IN 1797. THE TWO-STORY LOG HOUSE WAS BUILT BY ROSS'S GRANDFATHER, JOHN McDONALD. THE FUTURE PRINCIPAL CHIEF LIVED IN THE HOUSE OFF AND ON FOR TWENTY YEARS WHEN HE WAS YOUNG.

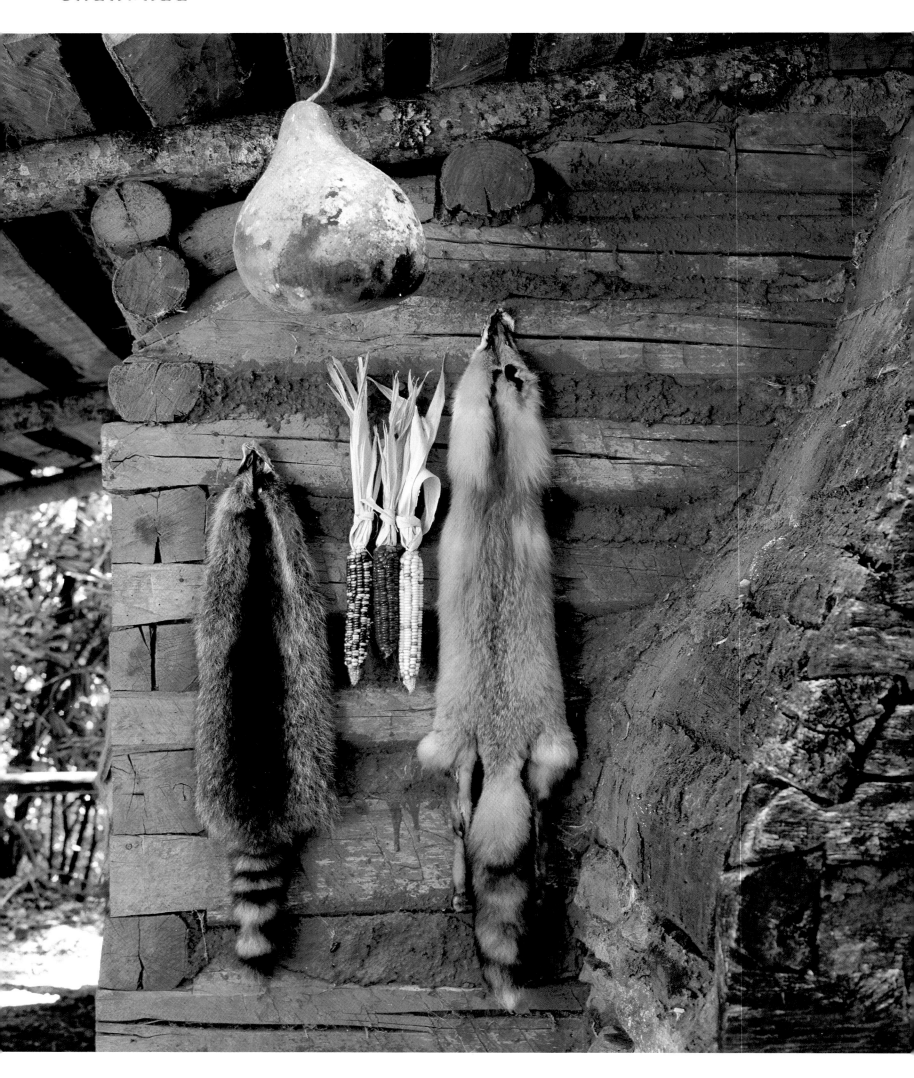

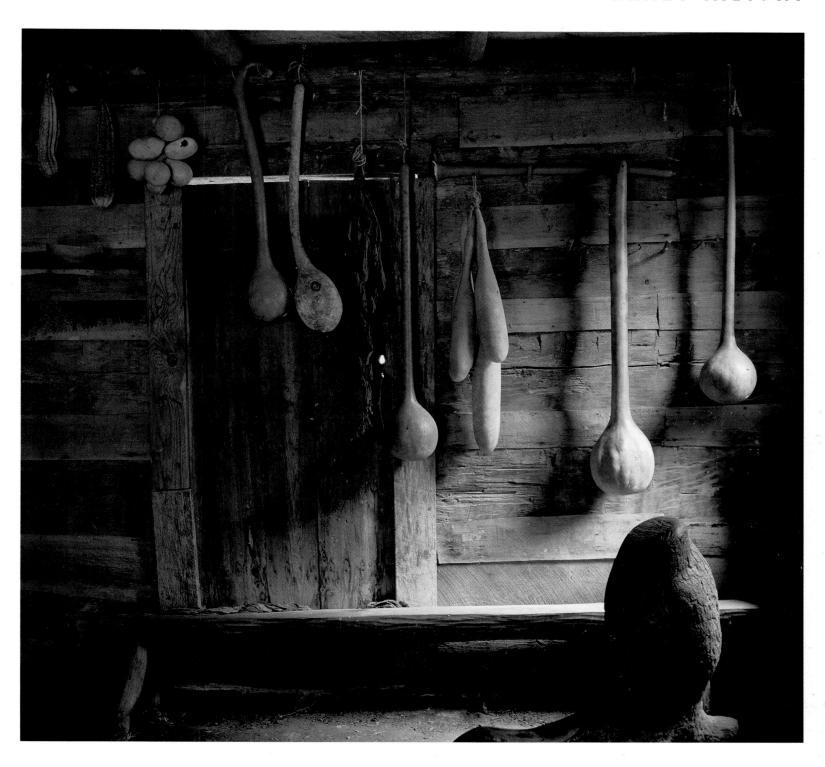

killed them all. Never again, the story concludes, did the Cherokees allow a powerful central government to develop among them.

As the various tribes in the region (what we now sometimes call the Old South) spoke a variety of languages, over the years a trade language had developed. It served the same purpose for the tribes of the old Southeast as did the Chinook jargon in the Northwest and the sign language for the Plains tribes. Known as the Mobilian trade language or jargon, it was based on the Choctaw language. The Choctaws called the Keetoowah People *Chalakees*, and because of the accessibility of the jargon, the Europeans soon picked up that same word. Before long everyone was using it, and eventually even the Keetoowah People accepted it and began using it themselves in the form *Chalagi*, or *Jalagi*. In English, it became Cherokee.

The first white men the Cherokees saw were members of the de Soto expedition traveling north from Florida in 1540 on their search for gold and leaving a bloody trail

◀◀ EXTERIOR OF CHEROKEE LOG HOUSE, 1750s. ITEMS THAT WERE PART OF TRADITIONAL CHEROKEE LIFE HANG ON THE WALLS, INCLUDING ANIMAL SKINS, GOURDS, AND CORN. OCONALUFTEE INDIAN VILLAGE, CHEROKEE, NORTH CAROLINA.

▲ INTERIOR OF AN ORIGINAL CHEROKEE LOG HOUSE FROM THE QUALLA RESERVATION, C. LATE 1800s.

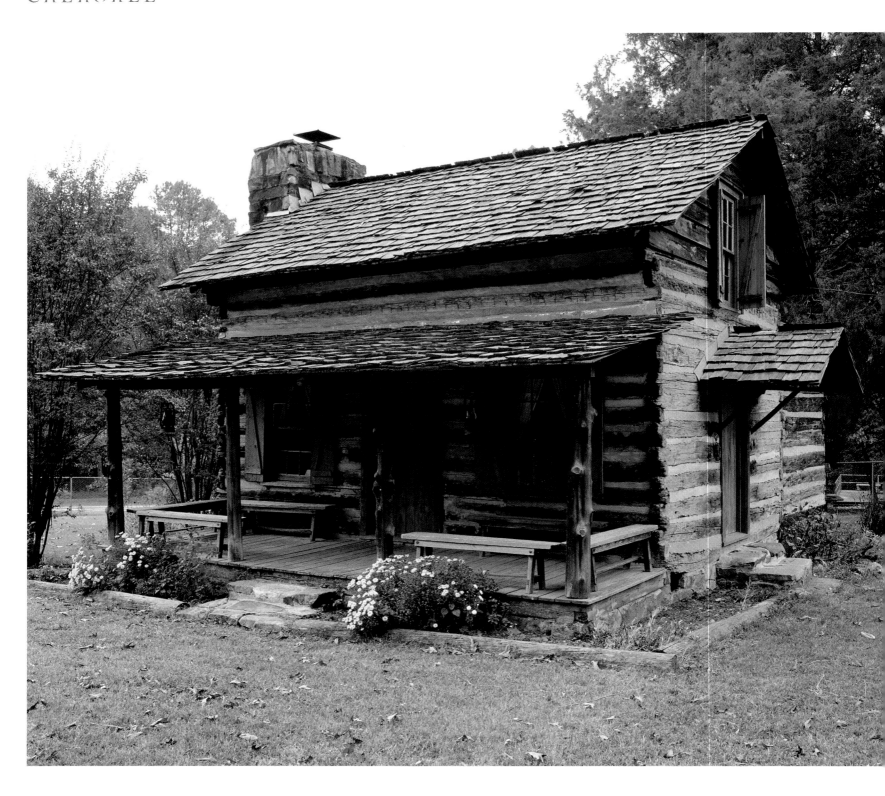

▲ SPRING FROG'S CABIN NEAR CHATTANOOGA, TENNESSEE. SPRING FROG, A CHEROKEE CHIEF WHO LIVED HERE PRIOR TO THE REMOVAL IN 1838–39, WAS A HUNTER, FISHERMAN, FARMER, AND BRAVE WARRIOR. HE FOUGHT WITH ANDREW JACKSON IN SEVERAL BATTLES DURING THE CREEK WAR. ELISE CHAPIN WILDLIFE SANCTUARY AT AUDUBON ACRES.

behind them. They seemed to have barely cut through Cherokee country and not to have caused many problems for the Cherokees. After that, the Cherokees were left alone for more than a hundred years. In 1673, two Englishmen from Virginia came to visit. Trade developed between the Cherokees and the British colonies, and along with it came a few conflicts. Most were resolved without too much trouble. But the French and the Spanish became involved as well as the English, and the Cherokees, along with other American Indian tribes, were drawn into the political intrigue of the Europeans on American soil.

The Cherokees and the English had a particular problem dealing with one another. The Cherokee towns were autonomous, so if the English wanted an agreement with the Cherokees, they had to try to get the same agreement with each individual town. Similarly, each English colony acted independently of the others. So the

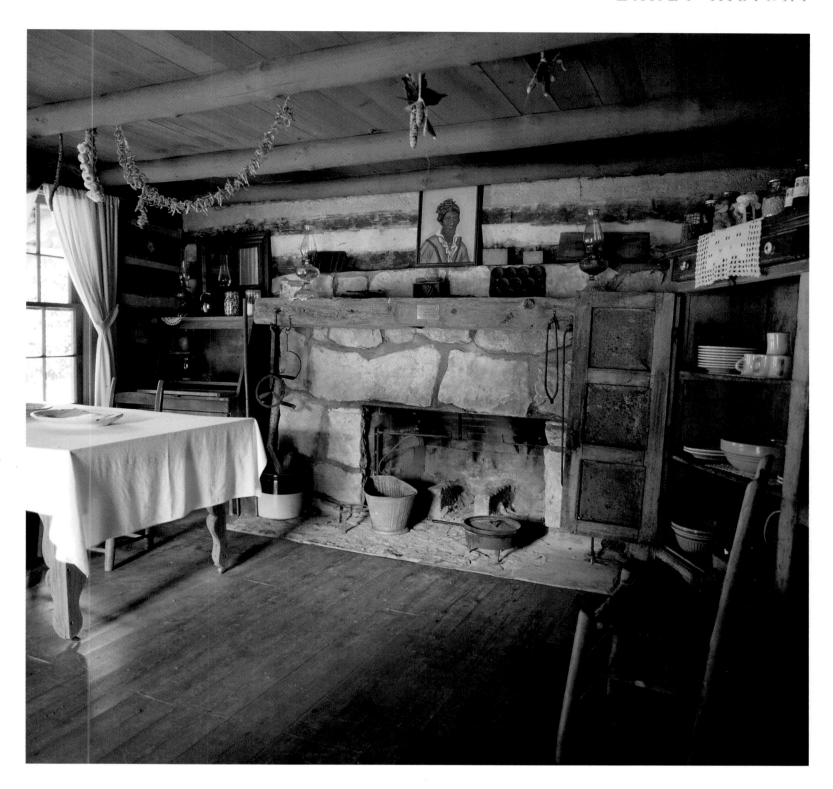

▲ INTERIOR OF SPRING FROG'S CABIN.

Cherokees could reach an agreement with one colony and still be at war with another.

In an attempt to resolve that cumbersome situation, in 1721 the English persuaded the Cherokees to appoint one man with whom they could deal on matters of trade. They wrote down his name as Wrosetasetow, a spelling that means nothing to Cherokee speakers. Little is known about him. When he died in 1736, he was replaced, apparently with some British influence, by a man the English called the "Emperor of the Cherokees." They wrote down his name as Moytoy. The man's name was almost surely Ama-edohi, meaning something like He's Walking on the Water. No doubt the Cherokees saw him, like his predecessor, as a sort of trade commissioner. Slowly but surely over the next several years, the trade commissioner evolved into a "Principal Chief," and the modern Cherokee Nation with a central government was conceived, although its full birth and growth would be gradual.

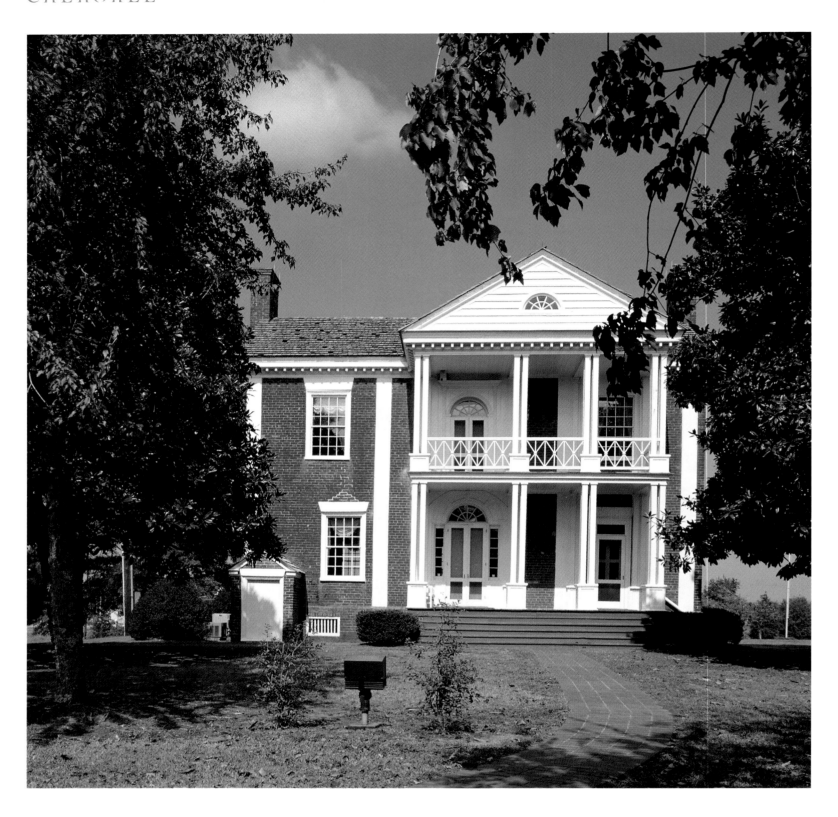

▲ THE VANN HOUSE, CHATSWORTH, GEORGIA. THE HOUSE WAS BUILT IN 1804 BY CHEROKEE JAMES VANN, A POLYGAMIST WHO HAD THREE WIVES AND FIVE CHILDREN. VANN WAS KILLED IN 1809, AND JOSEPH VANN, HIS SON, EVENTUALLY ACQUIRED THE HOUSE AND BECAME KNOWN AS "RICH JOE VANN." THE VANN FAMILY WAS REMOVED FROM THEIR HOME AND PLANTATION OVER THE TRAIL OF TEARS IN 1838–39 AND SETTLED AT WEBBERS FALLS, OKLAHOMA.

When Ama-edohi died in 1741, his son, Ammouskossittee (the English spelling of this Cherokee name cannot be deciphered), took over the office. He was apparently ineffective, so his uncle, Guhna Gadoga, Standing Turkey, known to whites as Old Hop, acted as his advisor, becoming the real power. After his nephew's death, he stepped formally and officially into the "emperor's" shoes. His son, Ukah-Ulah, followed him, and when he died in 1761, Ada-gal'kala, the first really significant political figure in early Cherokee history, came to the forefront.

Ada-gal'kala saw a void and stepped into the position. His name translates into English as Leaning Wood, but the English called him the "Little Carpenter." When they wrote down his Cherokee name in English, they spelled it Attacullaculla or Attakullakulla, and it appears that way in most histories about the Cherokees.

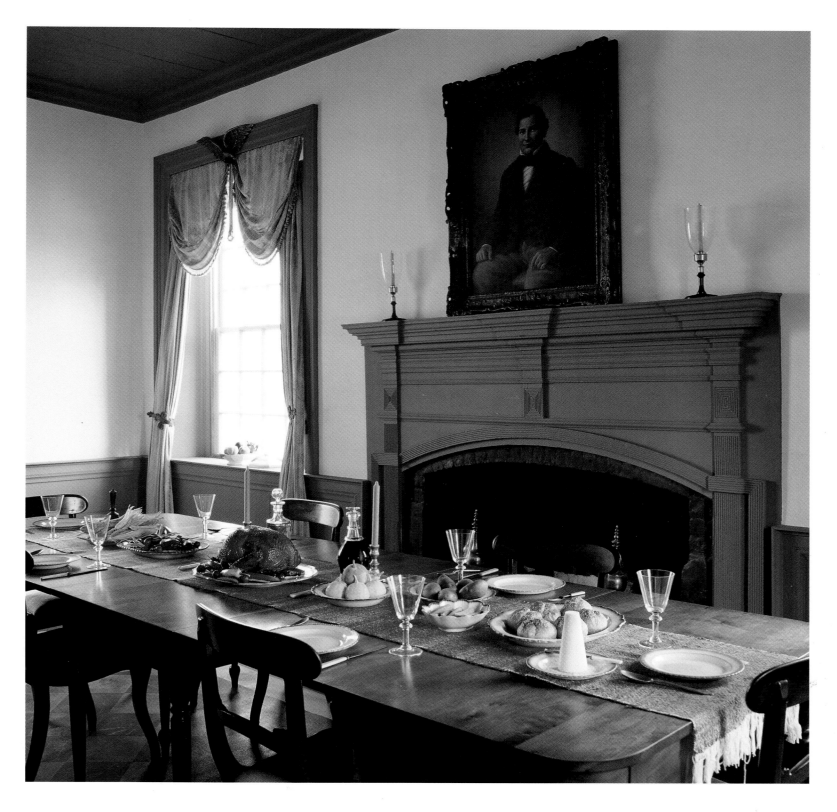

Ada-gal'kala had a reputation as a diplomat second to none, although his motives were sometimes suspect. Recognizing this new and evolving position for what it really was, Ada-gal'kala, on at least one occasion, referred to himself as the President of the Cherokee Nation.

Ada-gal'kala's greatest political rival was a war chief named Agan'stat', called Oconostota by the chroniclers of the time and later historians. Both of these men lived long lives and were prominent political figures, remaining powerful until the times of their deaths. Ada-gal'kala died first, and Agan'stat' stepped into his vacated position and was called the Principal Chief. The title is interesting and informative. The term *Principal Chief* acknowledges that there are yet other chiefs—in fact, two for each town.

When the American Revolution broke out, a faction of the Cherokee Nation,

▲ THE VANN DINING ROOM IN THE VANN HOUSE, CHATSWORTH, GEORGIA, 1804. A PAINTING OF JOE VANN HANGS OVER THE FIREPLACE.

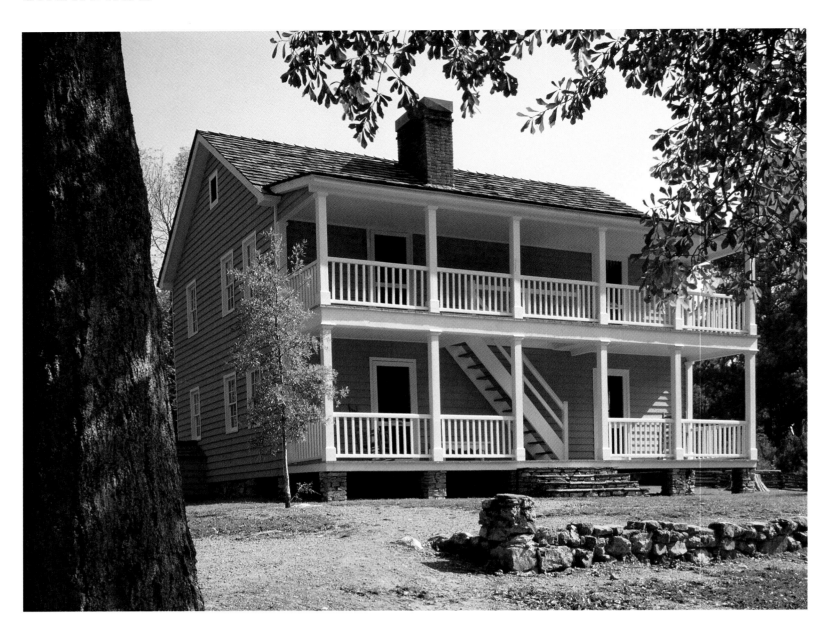

▲ THE WORCHESTER HOUSE, 1828, THE
ONLY ORIGINAL BUILDING TO SURVIVE AT
NEW ECHOTA, GEORGIA. CONSTRUCTED
BY THE REV. SAMUEL A. WORCHESTER,
THE STRUCTURE SERVED AS A PRESBYTERIAN
MISSION STATION AND ALSO AS THE
WORCHESTER FAMILY HOME. WORCHESTER
WORKED HARD TO PRESERVE THE
CHEROKEE NATION. HE IS BURIED NEXT
TO HIS FRIEND ELIAS BOUDINOT AT PARK
HILL CEMETERY, OKLAHOMA.

soon to be known as Chickamaugas, sided with the British, while the remaining
Cherokees, the official Cherokee Nation, attempted to remain neutral. The leader of
the Chickamaugas was a town war chief known as Tsiyu Gan'sini, or Dragging Canoe,
and his reasons for fighting alongside the British were clear and rational. The British
wanted to contain the colonies along the eastern seaboard. The "Americans" wanted to
move west onto Indian land. Dragging Canoe intended, with the help of the British,
to hold the line and keep the Americans off Cherokee land. Enough Cherokee land
had already been lost. Loyalists, or Tories, lived with the Chickamaugas and fought
alongside them against the rebels.

Of course, we all know, the Cherokees and the British lost that war. Citizens of
the new United States did move onto Cherokee land, demanding more and more from
the Cherokees. As early as 1802, President Thomas Jefferson formed a plan to move
all Indians to locations west of the Mississippi River. It was left to President Andrew
Jackson, however, to set that plan into motion. Dragging Canoe and his Chickamaugas
fought on after the war's end without British support, and other Chickamauga leaders
continued the fight for a short while even after the death of Dragging Canoe, by then
in his sixties. When the last of the Chickamaugas gave up the fight in 1794 (except
for some Cherokees' later involvement with the Confederate States of America),
Cherokees had fought their last war with the United States.

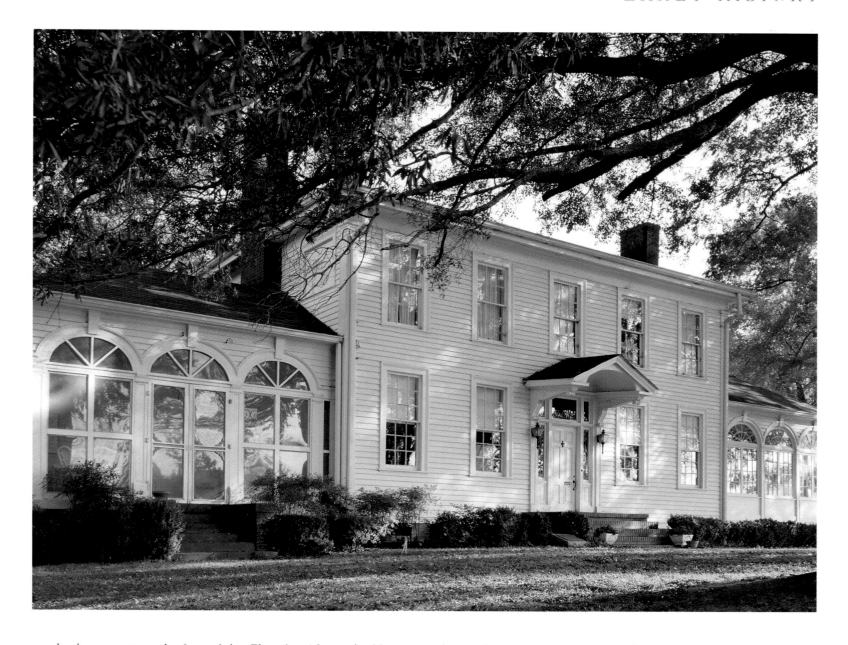

In the meantime, the face of the Cherokee Nation had begun to change. Many English traders had been living among the Cherokees since the late seventeenth century, and many British Tories had fought alongside the Chickamaugas. Some of both of these groups of whites stayed with the Cherokees at the war's end. Most of them had married Cherokee women, often partly to solidify trade relations. Some had been with the Cherokees so long and had started families in the Cherokee country that they felt at home. The Tories who stayed most likely felt much safer among the Cherokees than among the new white Americans. Mixed-blood families were formed with these marriages. One of those families was started by my own ancestor, an Irishman named Richard Pearis who had a license from the colony of North Carolina to trade among the Cherokees. (The spelling of the family name evolved into Parris.) Following the Revolution, however, Pearis did not stay with the Cherokees. Neither did he stay in the new United States. A Tory, Pearis fled to the Bahama Islands, leaving his Cherokee wife and son behind.

Slowly, Cherokee family structure changed from the old matrilineal clans to a European-style family with a male head of household. Clothing styles changed. Some Cherokees even became plantation owners and adopted the American institution of slavery. Under the strong influence of the growing mixed-blood population, a "progressive" faction of Cherokees developed. They sent their children to schools in

▲ MAJOR RIDGE'S HOME, ROME, GEORGIA, C.1794. THE HOUSE WAS BUILT BY MAJ. RIDGE; IT WAS MODERNIZED BY LATER OWNERS. HIS FERRY AND TRADING POST MADE THIS FARM A TRIBAL CENTER. IT IS NOW KNOWN AS THE CHIEFTAIN'S MUSEUM.

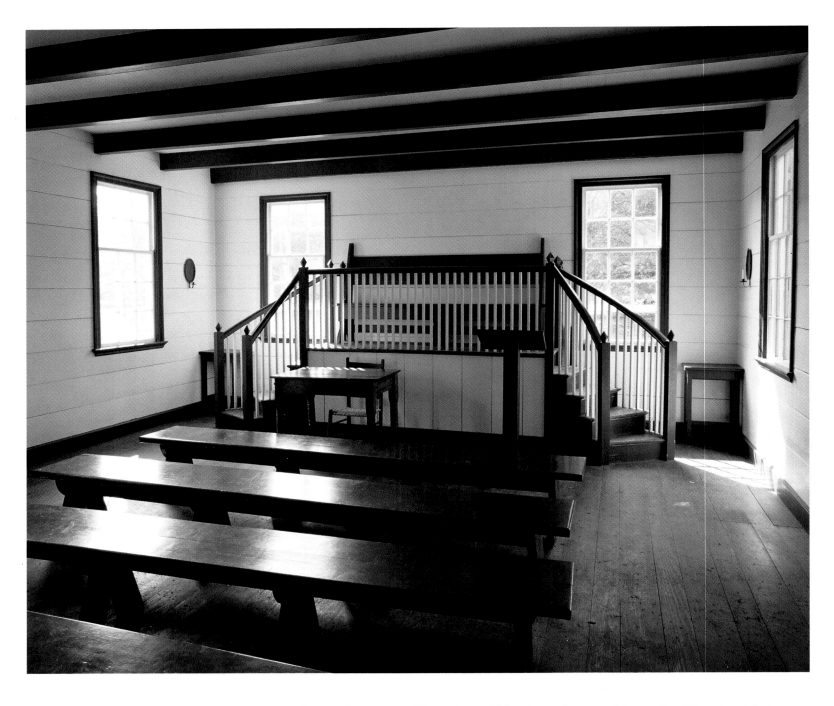

▲ Interior of Cherokee Supreme Courthouse (reconstructed) in New Echota, Georgia, established in 1825.

the northern states. They dressed like their white neighbors. The Cherokee Nation was divided into voting districts, and a written constitution was approved. A chief executive, called the Principal Chief, was elected by popular vote.

As early as 1792, some Cherokees had given in to the relentless pressures to move west. They had gone into Missouri and settled. The great earthquake of 1811 caused them to move again, this time into what is now northwest Arkansas. They built several small towns and called themselves the Western Cherokee Nation. The U.S. government dealt with them as a separate nation from the Cherokee Nation in the Southeast and signed treaties with them. Over the next several years, other groups of Cherokees from the old country moved west to join them.

But Principal Chief John Ross and the majority of Cherokees continued to resist removal. They maintained that no one had the right to tell them to give up their ancient homelands. Some, believing that the white southerners wanted them removed because they perceived them to be savage, set about changing the Cherokee lifestyle more rapidly and much more consciously. Working toward deliberate assimilation, reasoning that the white Americans would not object to having them for neighbors if

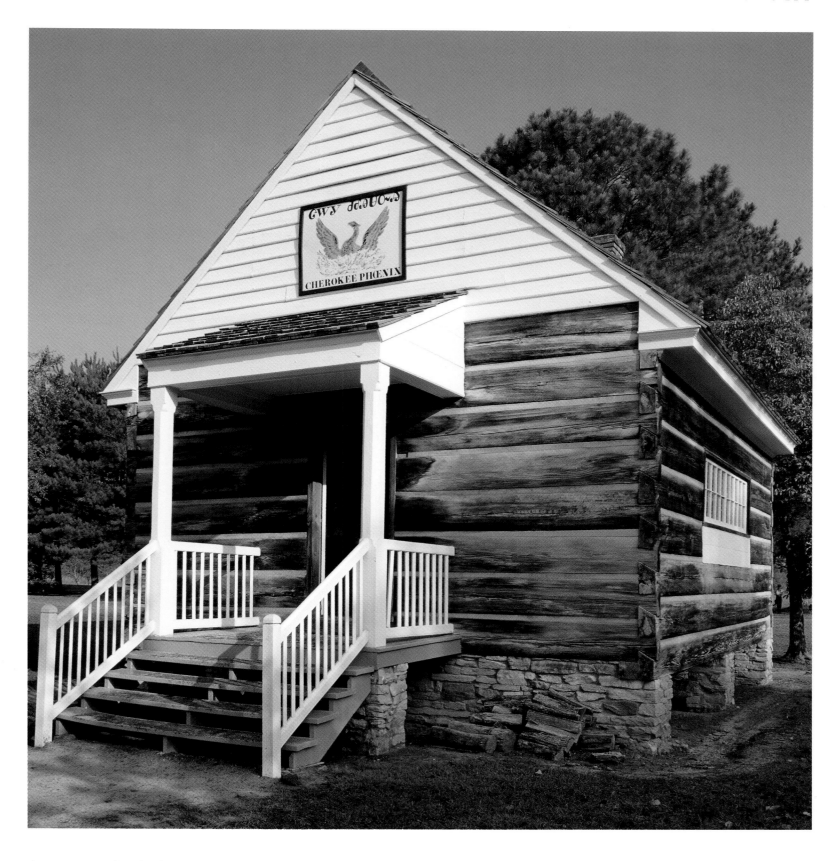

they were "civilized," they built schools and hired white teachers from colleges in the North. They built churches and invited missionaries to live and work among them. The Cherokee Nation was already divided into voting districts with the Principal Chief, Assistant Chief, and council members all being elected. Laws were written.

Then, in 1821, a remarkable thing occurred. An illiterate Cherokee, who could speak no English, presented the Cherokee People with a system of writing their language. Making use of this writing system, called the Cherokee syllabary, or the Sequoyah syllabary after its inventor, the Cherokee Nation began to publish a bilingual newspaper. But the pressures for removal not only continued but intensified.

▲ THE CHEROKEE GOVERNMENT PRINTING OFFICE AT NEW ECHOTA, GEORGIA, 1827. THE STRUCTURE IS A RECONSTRUCTION OF THE ORIGINAL BUILDING. THE *CHEROKEE PHOENIX*, A BILINGUAL NEWSPAPER, WAS PRINTED HERE WEEKLY FROM 1825–34. THOUSANDS OF BOOKS WERE TRANSLATED INTO CHEROKEE AND PUBLISHED HERE.

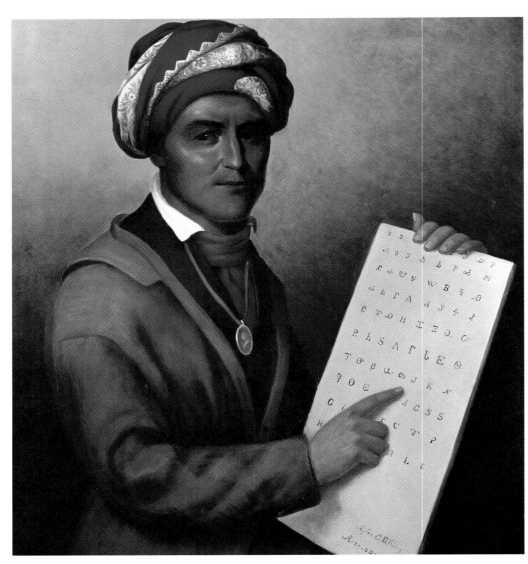

▲ PAINTING OF SEQUOYAH BY NARCISSA CHISHOLM OWEN (1831–1907), FROM A PAINTING BY CHARLES BIRD KING, DONE IN WASHINGTON, D.C., FROM LIFE, IN 1828. OIL ON CANVAS, 30 INCHES BY 30 INCHES. *Courtesy of the Oklahoma Historical Society.*

Sequoyah and the Cherokee Syllabary

Little is known of the life of Sequoyah, perhaps at once the best known and the least known of all the Cherokees. His statue stands in the Capitol Building, Statuary Hall in Washington, D.C. He has been called the Cherokee Cadmus, and for some strange reason the giant redwood trees of northern California have been given his name (but with a different spelling).

Sequoyah's English name is George Guess. Sequoyah's father may have been Nathaniel Gist, a Virginian and a trader to the Cherokees. Some have said that his father was a German named George Gist. And there are some Cherokees who insist that Sequoyah was a full-blood Cherokee. All seem to agree that his mother was a Cherokee woman named Wur-teh. Sequoyah was probably born around 1778.

The first we know of Sequoyah, he participated in the Battle of Horseshoe Bend in 1813, in which U.S. troops under the command of Andrew Jackson, including some Cherokees, defeated the Redstick Creeks under the leadership of William Weatherford, or Red Eagle. Sequoyah walked with a limp, but most historians and Sequoyah biographers believe that he had the limp before the battle.

Around 1820, Sequoyah became intrigued with the idea of reading and writing in the Cherokee language. He could not speak a word of English, much less read and write. But he maintained that if white men could do it, so could Cherokees. He tried making a mark for each word in the language, but soon gave that up. Then, somehow, he hit upon the idea of a syllabary, and within a year, he had perfected it. A syllabary is a system in which there is a symbol for each syllable in the language. For instance, in the Cherokee syllabary, the symbol "W" stands for the sound "la." "A" is "go." And so on.

Legend has it that Sequoyah's wife was totally frustrated with him. He was so absorbed in his syllabary that he neglected all his other work. Once she even burned down the house that he used as his "study," destroying all his notes in the process. He simply started over. Many Cherokees believed that he was dabbling in witchcraft with all those strange-looking marks he was making. Some simply considered him to be a harmless but worthless eccentric.

It took some doing, but Sequoyah finally convinced other Cherokees that the syllabary did work, and it was quickly and widely adopted by almost all Cherokees after that. The Cherokee Nation accepted it and began publishing a bilingual newspaper. Elias Boudinot wrote a novel in Cherokee, and the missionaries took advantage of the syllabary and had the New Testament translated and published in the Cherokee language. The whole Cherokee Nation became literate and a publishing program was under way.

In 1824, Sequoyah, his wife, Sally, and their children moved west to become part of the Western Cherokee Nation in what is now western Arkansas. Sequoyah became involved in politics and was sent to Washington, D.C., as a delegate. Following the Trail of Tears, the Western Cherokee Nation was moved across the line into what is now northeast Oklahoma and then reabsorbed into the larger Cherokee Nation. Sequoyah was instrumental in negotiations for the Act of Union that dissolved the Western Cherokee Nation and reabsorbed its citizenry into the Cherokee Nation. In the newly located Cherokee Nation, Sequoyah settled in what was called the Skin Bayou District, where he operated a saltworks. He was also a silversmith. The Cherokee Nation presented him with a medal for his contribution of the syllabary.

In 1842, Sequoyah, perhaps frustrated by the encroachment of whites into the Western Cherokee country, went on a search to find the Cherokees who had moved to Mexico years before. He found them, but he died in Mexico and was buried there. There have been several unsuccessful Cherokee-sponsored expeditions to Mexico, attempting to locate Sequoyah's grave.

The Cherokee Nation changed the name of the Skin Bayou District to the Sequoyah District, just one of the many honors that have been bestowed on this great and enigmatic figure in Cherokee history.

▶ A Cherokee primer in the Cherokee language, 1846. The primer was printed at Park Hill Mission Press by John Candy. It was in the Cherokee time capsule buried in 1847, Northeastern State University, Tahlequah, Oklahoma.

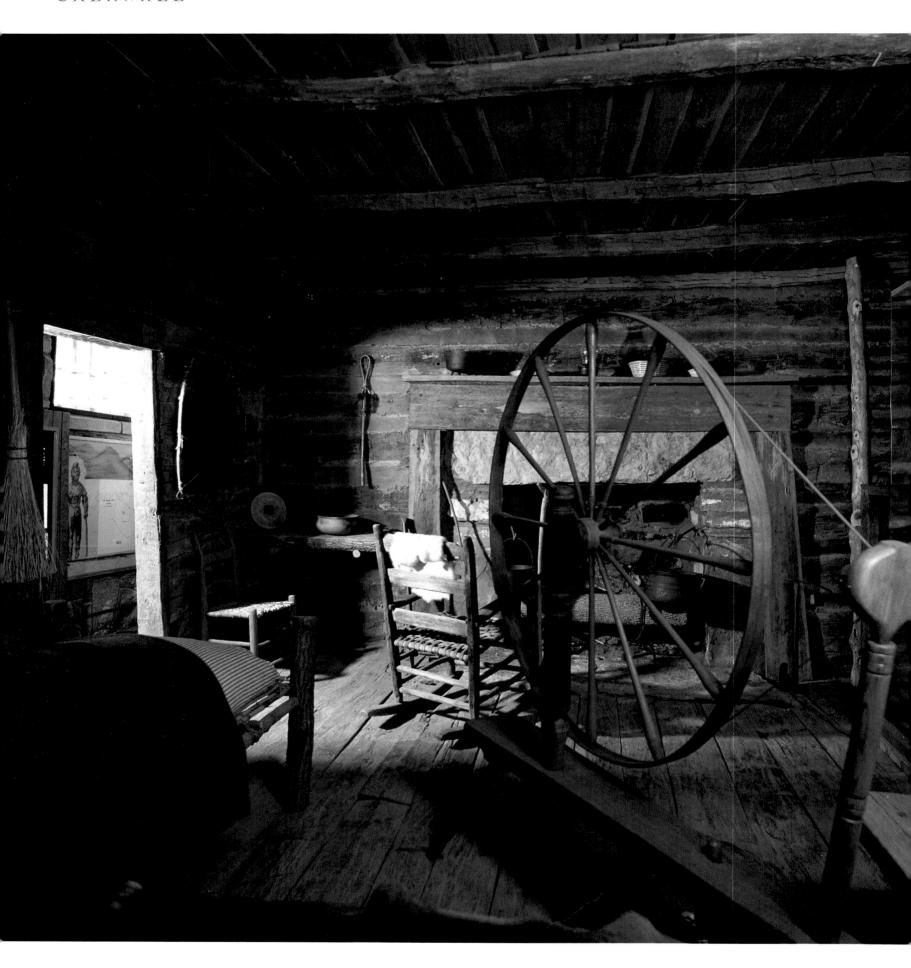

▲ SEQUOYAH'S LOG CABIN, 1828. SEQUOYAH
MOVED WEST IN 1824 AND IS BELIEVED TO
HAVE BUILT THIS ONE-ROOM LOG DWELLING.

In 1830, at President Andrew Jackson's urging, Congress passed the Indian Removal
Act. The pressure was now coming from not only the individual southern states,
particularly Georgia, but also from the federal government. The Cherokee Nation,
under the leadership of Chief Ross, resisted removal still, taking the case all the way to

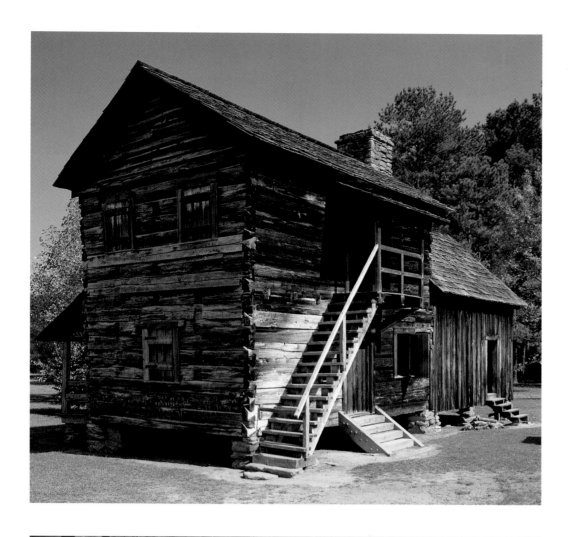

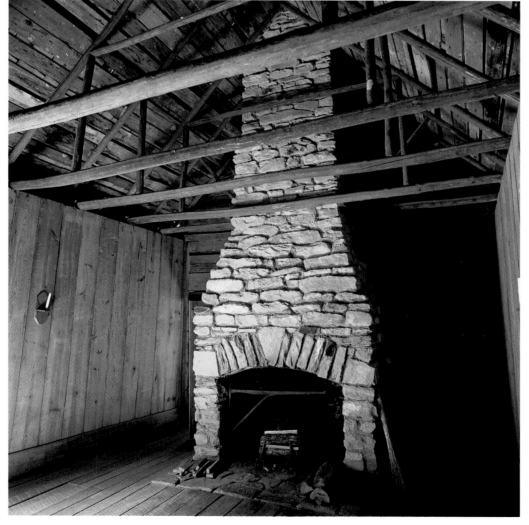

▲ THE VANN TAVERN, NEW ECHOTA, GEORGIA, C. 1805. THE TAVERN WAS ORIGINALLY BUILT BY JAMES VANN NEAR THE CHATTAHOOCHEE RIVER IN WHAT IS NOW FORSYTH COUNTY, GEORGIA. IT SERVED TRAVELERS ON THE FEDERAL ROAD AS A RESTAURANT, STORE, AND INN.

◄ THE FIREPLACE IN THE VANN TAVERN IS ORIGINAL.

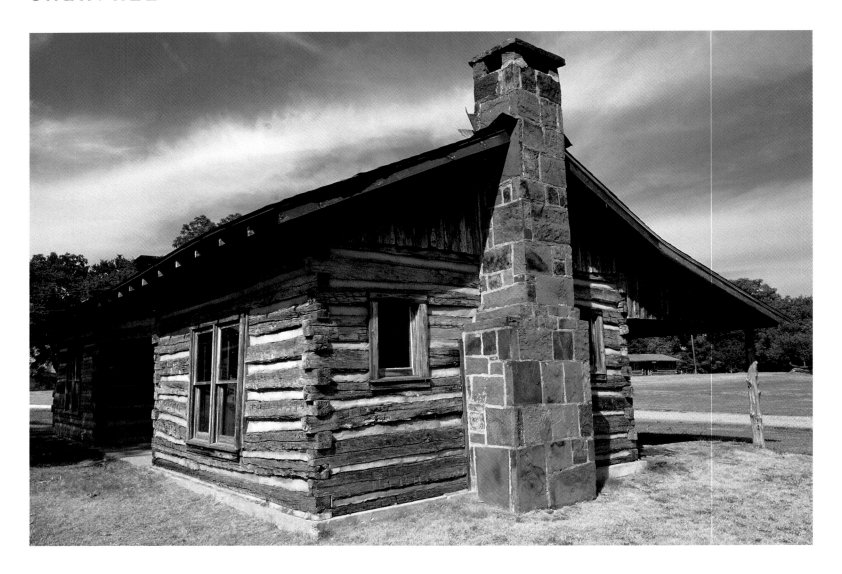

▲ Dwight Presbyterian Mission, established first in Arkansas in 1821, was moved to Indian Territory (now part of Oklahoma) in 1829. Dwight Mission School opened in 1830. None of the original school buildings remain, but many logs from the "Blue House" (the last original school building destroyed) were incorporated into this museum cabin on the grounds.

the U.S. Supreme Court. There they won the case, but President Jackson thumbed his nose at the high court. He said that Chief Justice John Marshall had "made his decision. Now let him enforce it." Some Cherokees were so disheartened by the news of Jackson's attitude that they gave up the struggle and agreed to sign a Removal Treaty.

The Treaty of New Echota, a treaty of total removal, was signed December 29, 1835, by a group of individual Cherokees, several of whom were prominent Cherokee citizens, but none of whom had any official position in the government of the Cherokee Nation. The treaty was fraudulent, but it was accepted as valid by the United States. In 1838, the U.S. Army was sent into Cherokee country to force Cherokees from their homes. The Cherokee people were gathered and held in stockade prisons to await removal to the West. People sickened and died in these primitive and unsanitary camps.

One Cherokee resisted. A man named Tsali and his sons fought back when soldiers came to his home to force his family out of the house and down the mountain into the stockades. Some soldiers were killed, and Tsali and his family fled into the hills. Tsali and his sons were later captured and shot by a firing squad made up of other Cherokees, forced into that unpleasant duty by the U.S. Army. One version of the tale has it that word was sent to Tsali that if he would give himself up, the army would stop its hunt for Cherokee people in the hills. Those who thus avoided the roundup are the ancestors of today's Eastern Band of Cherokees in North Carolina.

When enough people had been gathered, they were headed west over what would become known as the Trail of Tears. The first group was taken west by the U.S. Army

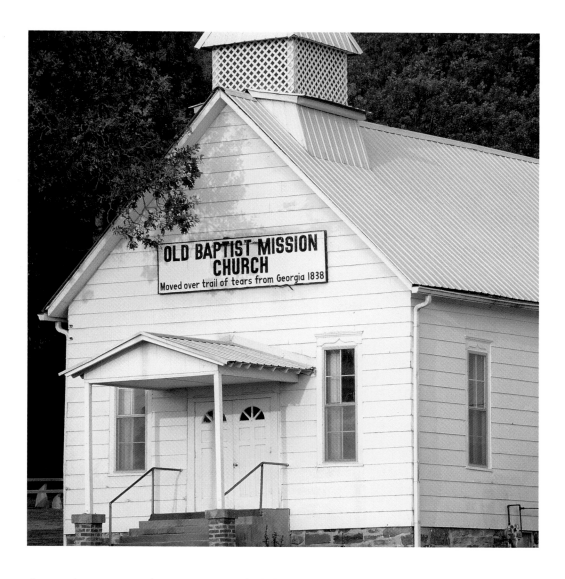

during the summer of 1838, a particularly hot and humid summer. The trail was strewn with the graves of those who could not make it, mostly the very old and the very young. Chief Ross saw that the Removal was inevitable at that point, and he reasoned that the Cherokee Nation could accomplish the move better than could the U.S. Army. He applied to the army to contract with the Cherokee Nation to complete the Removal for themselves.

The next thirteen waves of the Removal were conducted by Cherokee captains, but months had gone by and winter had set in. Two waves were trapped during a bitter winter in extreme southern Illinois between the frozen Mississippi and Ohio Rivers, where many people sickened and died from exposure to the severe cold. Altogether, the Removal took several months to complete. The first wave under a Cherokee captain left the old country on August 28, 1838. The last one arrived in what is now northeast Oklahoma on March 18, 1839. It has been estimated that one-fourth of the Cherokee population died along the way. One of them was Quatie, the full-blood wife of Principal Chief John Ross. It is said that she became ill and died as a result of having given her only blanket to a child.

Those who survived found themselves in a new land, needing to rebuild from nothing. But by then, the new lifestyle and attitudes, modeled on those of white settlers, had set in firmly with many Cherokees, and so the rebuilding took place along the lines of that new lifestyle. Homes were usually log cabins, much like those of frontier whites. Towns were built that resembled the towns of frontier whites. A capital was established and called Tahlequah. (There are stories about the origin of the capital's

◄ BAPTIST MISSION CHURCH, TAHLEQUAH, OKLAHOMA. THE REV. JESSE BUSHYHEAD SETTLED IN TAHLEQUAH IN 1839 FOLLOWING THE REMOVAL OF THE CHEROKEES OVER THE TRAIL OF TEARS. A BAPTIST MISSION WAS ESTABLISHED HERE BY THE REV. EVAN JONES IN 1841. THE ORIGINAL MISSION STATION WAS BURNED BY CONFEDERATES DURING THE CIVIL WAR. THE CURRENT CHURCH BUILDING WAS CONSTRUCTED IN 1888.

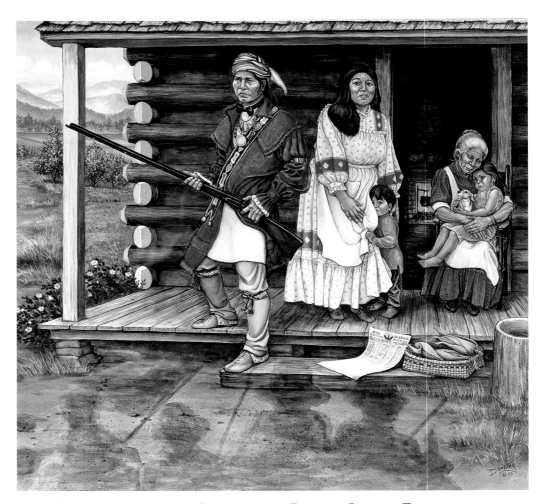

▲ *BUT THIS IS MY HOME,* 1998, BY CHEROKEE ARTIST DOROTHY SULLIVAN. THE PAINTING DEPICTS THE FORCED REMOVAL OF THE CHEROKEES FROM THEIR LAND IN THE OLD CHEROKEE NATION TO INDIAN TERRITORY. *Collection of Jack D. Baker, Oklahoma City.*

The Trail of Tears

Eastern Americans, especially southeastern Americans, had been clamoring for Indian lands for as long as they had been around. As early as 1802, the state of Georgia signed an agreement with President Thomas Jefferson, known as the Georgia Compact, or the 1802 Compact. By the President's signature on this agreement, the United States agreed to "extinguish" the title of any Indian land in Georgia and remove the Indians from within the boundaries of Georgia "as soon as possible."

In 1792, a group of Cherokees had left the old homelands and moved into Missouri. Following the massive earthquake of 1811, they moved farther west into what is now western Arkansas. They styled themselves the Western Cherokee Nation, and the United States negotiated with them as such. Agents of the United States began circulating among the Cherokees in the old country, using the Western Cherokee Nation as an argument. Didn't the Cherokees want to join their brothers in the West? Didn't they want to get out of reach of the white man and settle on lands where the hunting was still good? A few Cherokees accepted that reasoning and made the move.

By 1830, Georgia and the other southern states were tired of waiting. They began applying pressure on the U.S. government to live up to its agreement, and the Indian Removal Act, pushed by President Andrew Jackson, was passed in the U.S. Congress by only one vote. The Cherokee Nation resisted Removal, taking the case to the U.S.

Supreme Court, where they won. But President Jackson defied the ruling of the Court saying that Chief Justice "Marshall has made his decision. Let him enforce it." At that point, a group of Cherokees, headed by Major Ridge, his son John Ridge, and Elias Boudinot, later to be known as the Treaty Party, seeing no further hope, gave in to the pressures of Georgia and of the U.S. government. Believing that they had gone as far as they could go, to no avail, they agreed to sign a fraudulent treaty with the federal government. The signers did not represent the government of the Cherokee Nation. The Treaty of New Echota, also called the Removal Treaty, signed December 29, 1835, was nevertheless ratified by the Senate and considered by the U.S. government to be binding on the Cherokees. The treaty took away all Cherokee land in the East in exchange for seven million acres in what is now northeast Oklahoma, $5 million, and a perpetual outlet west. This land, the treaty promised, would never be included within the boundaries of any state or territory. While the Treaty Party began moving west voluntarily, the majority of Cherokees, under the leadership of Principal Chief John Ross, stubbornly maintained their right to remain on their lands.

Georgia launched an intensive campaign designed to harass the Cherokees into accepting Removal. The Georgia legislature passed a series of laws known as the "Anti-Cherokee laws," which forbade Cherokees to dig gold on their own land, prohibited a Cherokee from testifying in court against a white man, and prevented any white man (including the missionaries who were already there) from going into the Cherokee Nation without having first signed an oath of loyalty to the state of Georgia.

In 1838, the U.S. Army began driving Cherokees out of their homes, rounding them up, and placing them in stockade prisons. Conditions in these primitive prisons were almost unbearable. Sanitation was minimal, and sickness spread. People died. When enough had been gathered, the army started the first group on their way west. The trip was disastrous, with many people dying along the way. Seeing that Removal was going to happen no matter what, Chief Ross petitioned the United States to allow the Cherokee Nation to conduct its own Removal. The petition was accepted, and the remaining Cherokees, still held in stockades, were divided into thirteen contingents, called "waves." Each wave was assigned a captain.

By the time the last wave reached its destination in what is now northeast Oklahoma, it has been estimated that one-fourth of the Cherokee population of approximately twenty thousand had died along the way. It is known, also, from logs kept along the way, that many Cherokees slipped away in the darkness each night simply to vanish from history. Once the Removal was complete, some members of the majority party, those who had suffered the forced Removal, began to assassinate the treaty signers. Treaty Party members retaliated, and for several years, the Cherokee Nation suffered from internal strife and violence.

▶ OLD CHEROKEE BASKET, C. 1838. THE BASKET IS SAID TO HAVE COME OVER THE TRAIL OF TEARS. *Collection of Bacone College, Muskogee, Oklahoma.*

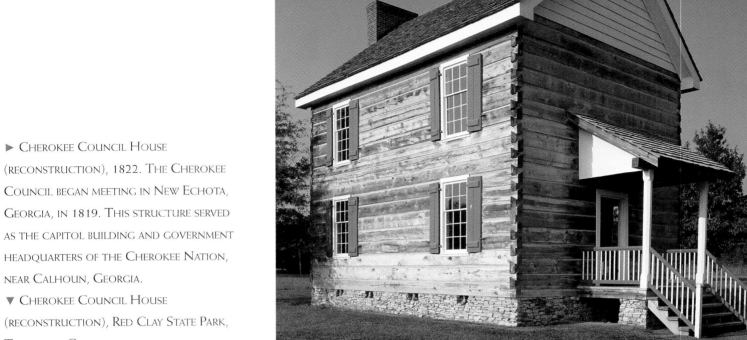

► CHEROKEE COUNCIL HOUSE (RECONSTRUCTION), 1822. THE CHEROKEE COUNCIL BEGAN MEETING IN NEW ECHOTA, GEORGIA, IN 1819. THIS STRUCTURE SERVED AS THE CAPITOL BUILDING AND GOVERNMENT HEADQUARTERS OF THE CHEROKEE NATION, NEAR CALHOUN, GEORGIA.

▼ CHEROKEE COUNCIL HOUSE (RECONSTRUCTION), RED CLAY STATE PARK, TENNESSEE. CHEROKEE LEADERS MET IN THIS MEETING PLACE FROM 1832 TO 1838.

name. One says that three men were supposed to meet to determine the location of the capital. Two met and waited for the third. Finally one of the two said, *"Tahli eliqua,"* meaning "Two is enough." A slight variation of the tale has it that the men were supposed to be searching for a spot where three streams came together. They found a nice place, but there were only two streams. One man made the same response as in the previous version of the tale. Although the stories seem to make sense linguistically, they are almost surely apocryphal, and the truth seems to be that Tahlequah is simply a slightly different Anglicization of an old Cherokee place-name that is still in use in Tennessee as Tellico, an ancient name that can no longer be translated.

A capitol square was laid out, and a large shelter was constructed, similar to an oversized arbor. It was a place where many people could gather and listen to addresses by the Principal Chief or other speakers or take part in meetings. In two corners of the square, small log cabins were built to serve as governmental offices. Eventually a two-story, brick capitol building was erected on the square in place of both the shelter and the cabins.

But there was more going on in the newly located Cherokee Nation than building. Some of the people who had suffered and survived the forced Removal, and were

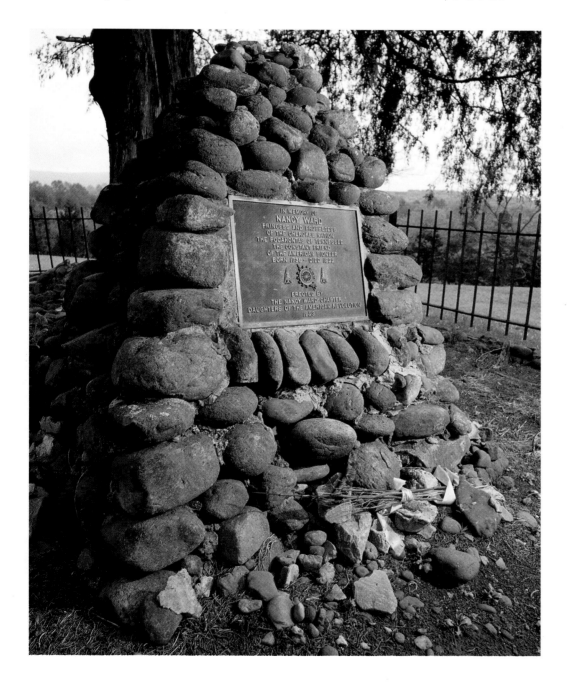

◀ THE GRAVE OF NANCY WARD (1738–1822) AND HER SON FIVEKILLER, SOUTH OF BENTON, TENNESSEE.

▲ Reenactment of the Civil War battle of Honey Springs, July 17, 1863. The battle was known as the Gettysburg of the West, and was fought near Checotah, Oklahoma.

The Civil War in the Cherokee Nation

When the white man's Civil War broke out, the spirit of rebellion was soon caught by some Cherokees. Principal Chief John Ross meant for the Cherokee Nation to remain neutral and out of the war, and he wrote to the President of the United States requesting that troops be sent to the Cherokee Nation to ensure that neutrality. The United States had promised to protect the Cherokee Nation from both invasion and domestic strife in the Treaty of New Echota. The request was ignored.

Stand Watie and other Cherokees, mostly members of the old Treaty Party, still rankling from their recent conflict with and loss to the majority Ross Party, decided to fight for the Confederacy. Seeming to have forgotten the hostility of Georgia and other southern states, they said that it was the United States that had done them wrong, and, after all, they were southerners. Many Cherokees had been owners of large plantations back in the old Cherokee country, and many Cherokees, including Chief Ross, were still slave owners. Watie raised a regiment and was accepted into the Confederate Army with the rank of Colonel. Watie and his followers declared a Confederate Cherokee Nation with Stand Watie as Principal Chief. Eventually, the Confederacy promoted Watie to General.

Without U.S. troops to protect the neutrality of the Cherokee Nation, other Cherokees, mostly full-bloods, organized themselves against Watie's Confederates. These were called Union Indians, or Pin Indians. Many, if not all, of the Pin Indians were also members of the Nighthawk Keetoowah Society and were followers of the Baptist missionary Rev. Evan Jones, an ardent abolitionist.

Although the Confederate Cherokees did leave the Cherokee Nation for a couple of battles, Union and Confederate Cherokees mostly stayed at home and fought each other, having, for all practical purposes, a civil war within the Cherokee Nation that more or less mirrored the larger one in the United States.

The Civil War raged wildly in the Cherokee Nation, with most buildings and homes, including the home of Chief Ross, being burned to the ground. At one point, Chief Ross signed a treaty with the Confederacy under duress, but he fled the Cherokee Nation and repudiated the Confederate treaty at his first opportunity. Many Cherokees fled their homes, seeking refuge in Kansas, Arkansas, Texas, and other places. The war left so many orphaned Cherokee children that the Cherokee Nation established an orphanage to care for them. Stand Watie became the last Confederate general to surrender.

At the end of the war, when the refugees returned to their homes, they found that they had lost everything. The U.S. government used the short-lived Confederate treaty as a convenient excuse to force a new treaty on the Cherokee Nation, as well as the other four of the so-called Five Civilized Tribes. This treaty formed the five independent Indian republics into the newly organized U.S. "Indian Territory." It also severely limited the powers of the Cherokee courts and gave the federal court in Arkansas jurisdiction over the new Indian Territory. It was a first and obvious step toward statehood and the near annihilation of the governments of the five Indian Nations.

▲ Pea Ridge, Arkansas, March 7, 1862, the first Civil War battle in which Indian troops participated. Two regiments of Cherokees, about one thousand men, fought here in the Confederate Army.

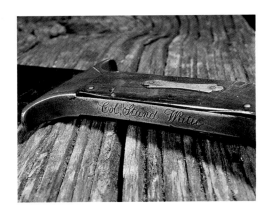

▲ ENGRAVING ON THE BOWIE KNIFE OF STAND WATIE (BEFORE HE WAS A BRIGADIER GENERAL) READS "COL. STAND WATIE," C. 1862. *Cherokee Heritage Museum, Tahlequah, Oklahoma.*

▶ LETTER OF SURRENDER BY BRIGADIER GENERAL STAND WATIE. WATIE WAS THE ONLY NATIVE AMERICAN ON EITHER SIDE TO RISE TO THE RANK OF BRIGADIER GENERAL DURING THE CIVIL WAR. ON JUNE 23, 1865, HE OFFICIALLY SURRENDERED HIS COMMAND OF THE FIRST INDIAN BRIGADE, C.S.A. TO FEDERAL AUTHORITIES AT DOAKSVILLE, NEAR FORT TOWSON IN THE CHOCTAW NATION. *Collection of Northeastern State University, Tahlequah, Oklahoma.*

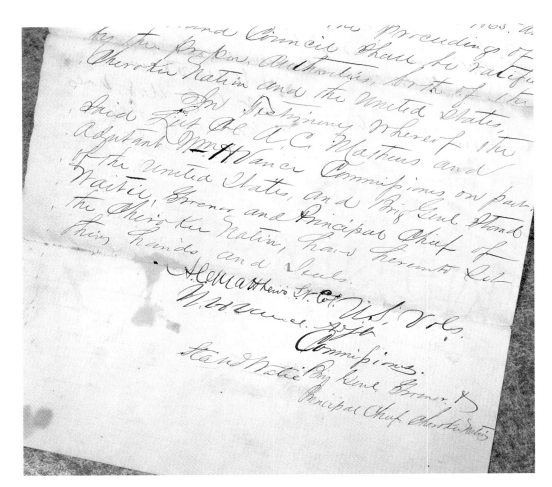

unable to strike back at the U.S. government, blamed all their miseries on the Treaty Party, those Cherokees who had signed the Treaty of New Echota. Invoking an old tribal law that called for the death of anyone who sold Cherokee land, they began to systematically assassinate the signers of the treaty.

The members of the Treaty Party had moved west voluntarily and attempted to blend in with the members of the Western Cherokee Nation, so the civil unrest that followed is sometimes viewed as a conflict between the Cherokee Nation and the Western Cherokee Nation. It did not help matters that the Cherokee Nation and the United States wanted the Western Cherokee Nation to dissolve itself and have its citizens become part of the larger Cherokee Nation. The Western Cherokee Nation resisted, but at last an Act of Union was signed, and the Western Cherokee Nation did in fact cease to exist. The violence slowed and an unsteady peace set in. By the early 1840s, the Cherokee Nation entered into what has been called by historians its Golden Age.

Schools were built. The Cherokee Nation established probably the first free, compulsory, public-school system in the world, and many of the teachers in that system were Cherokee citizens. White people in Arkansas paid tuition so that their children could attend the Cherokee schools. The first institutions of higher education west of the Mississippi River were built by the Cherokee Nation: the Cherokee Female Seminary and the Cherokee Male Seminary. At a time when it was illegal in many of the southern states to educate Blacks, the Cherokee Nation established a school for "Coloreds" in downtown Tahlequah. The newspaper, renamed the *Cherokee Advocate,* was reestablished. The Cherokee Nation was prospering and growing. But it was not to last.

When the Civil War began between the northern and southern states of the United States, the Cherokee Nation was drawn into the conflict. Members of the old

Treaty Party, led by Stand Watie, saw the Civil War as an opportunity to attack the John Ross government. Watie, whose brother, Elias Boudinot, had signed the treaty and had later been killed for that act, raised a Cherokee regiment for the Confederacy. A Confederate Cherokee Nation was declared with Watie as not only the general of its army but also its Principal Chief. In reaction, many full-blood Cherokees organized themselves into Union Indians, known as Pin Indians because of identifying pins worn under their coat lapels. The Cherokee Nation was devastated by the Civil War. Most homes and other buildings in the Nation were burned. Livestock was destroyed or driven off. People fled to Arkansas, Texas, or Kansas for safety.

When those refugees returned to the Cherokee Nation at the end of the war, they found that they had nothing left. Once again, they had to start all over. But that was not the worst of it. The United States forced yet another treaty on the Cherokee Nation. Because the Cherokee Nation had fought with the Confederacy, the government said, it had to be punished. Land was taken. The Cherokee Nation and the other of the so-called Five Civilized Tribes—the Creeks, Choctaws, Chickasaws, and Seminoles— were organized into Indian Territory. A federal court at Van Buren, Arkansas, later moved to Fort Smith, was given jurisdiction over the new Indian Territory.

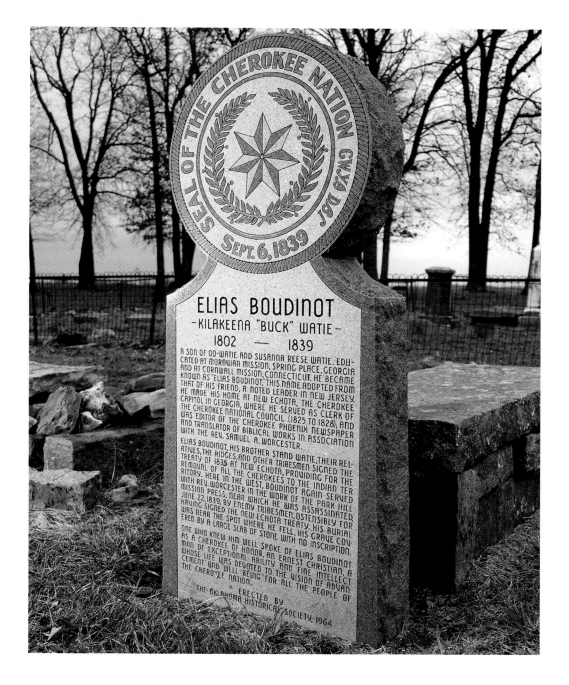

◄ THE GRAVE AND MEMORIAL OF ELIAS BOUDINOT, 1839, PARK HILL, OKLAHOMA. THE GRAVESITE IS NEAR THE SPOT WHERE BOUDINOT WAS KILLED ON JUNE 22, 1839. HIS BROTHER, STAND WATIE, ESCAPED. HIS UNCLE AND HIS COUSINS, THE RIDGES, WERE ALL KILLED FOR SIGNING THE TREATY OF NEW ECHOTA.

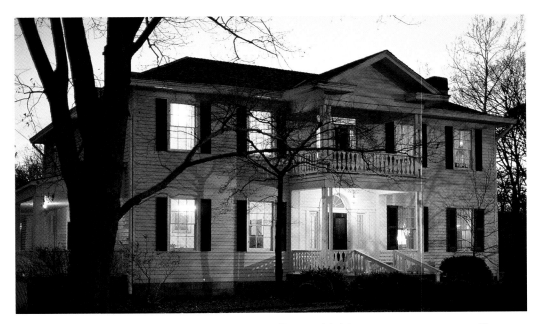

▲ Murrell Home, or "Hunter's Home," 1845. George M. Murrell was a native of Virginia and, in 1834, married Minerva Ross, the niece of Principal Chief John Ross. The Murrell Home is the only remaining antebellum plantation home in Oklahoma. It is a reminder of the high lifestyle practiced by some in the Cherokee Nation before the Civil War.

The "Five Civilized Tribes"

In the 1820s and '30s, the Cherokee Nation and its four nearest neighboring tribes, the Choctaws, Chickasaws, Creeks, and Seminoles, had already undergone considerable assimilation into the culture of the invading white man. Most of this was a result of the use of trade goods and of a significant number of mixed marriages. But the pressures of the governments of the southern states and of the federal government to move all Indians to new homes somewhere west of the Mississippi gave rise to a strange phenomenon. As if to say, "The white man doesn't want us for neighbors because he perceives us to be savages," the Cherokees in particular and the other four tribes as well began to deliberately acquire more and more of the habits and attitudes of the whites.

In the Cherokee Nation, individual Cherokees became slave-holding plantation owners. Cherokees became merchants and began to accumulate wealth. They organized a new government modeled on that of the United States. Many sent their children to schools in the Northeast. They invited missionaries to move in among them, and they built schools in the Cherokee Nation, hiring teachers from prestigious universities. The Cherokee Nation published a newspaper. They were so successful at imitating the society of the white man that they and their four neighboring tribes became known as the "Five Civilized Tribes." And in all this effort to change, some traditional customs and ways of life became lost to the Cherokee People.

The effort was meaningless to their white neighbors, however, who, as it turned out, simply wanted the Cherokees' land. But the movement was already established and nothing could stop it. At the end of the Trail of Tears, each of the so-called Five Civilized Tribes once again began to build schools and churches, merchants reestablished their businesses, and in many cases, they outdid their new white neighbors in Arkansas, Texas, and Kansas at their own game.

Today, many Native Americans feel that the term "Five Civilized Tribes" is

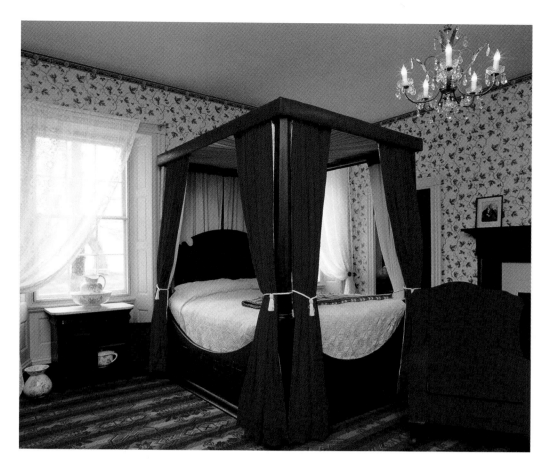

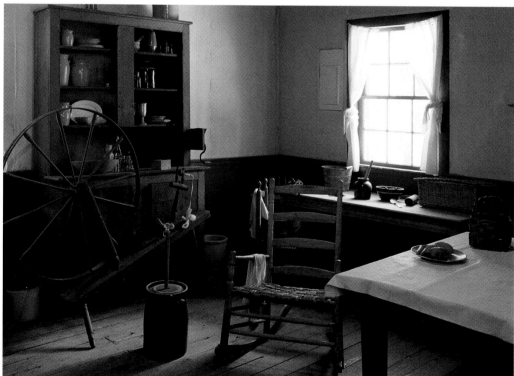

inappropriate, in that it implies that those tribes were uncivilized before they began to imitate the white man, when in fact their traditional civilizations were simply much different from those that Europeans brought with them to America.

▲ ▲ WASHSTAND, BED, AND CHAIR OF GEORGE MURRELL HOME, 1845.
Collection of the Cherokee Heritage Center.
▲ KITCHEN, MURRELL HOME, 1845. THE HUTCH AND SPINNING WHEEL ARE BELIEVED TO BE ORIGINAL.

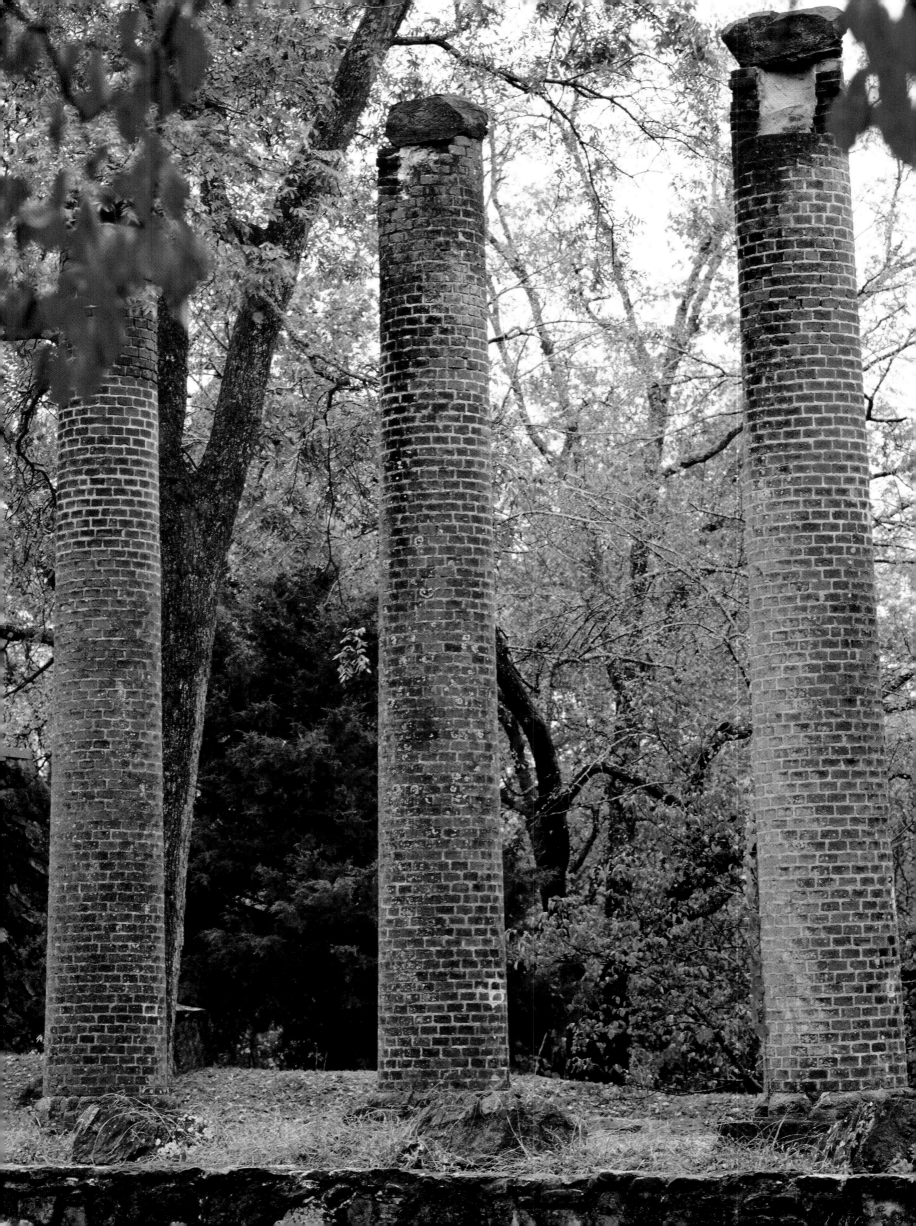

INDIAN TERRITORY

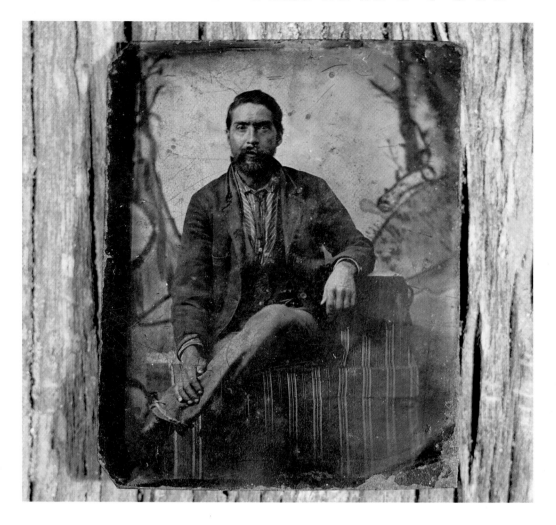

◄◄ COLUMNS FROM THE ORIGINAL CHEROKEE NATIONAL FEMALE SEMINARY, WHICH BURNED IN 1887, TAHLEQUAH, OKLAHOMA.

◄ TINTYPE OF EZEKIAL, OR ZEKE, PROCTOR, TAKEN IN THE 1880s. AS A BOY, ZEKE CAME OVER THE TRAIL OF TEARS AND LATER BECAME FAMOUS WHEN HE ACCIDENTALLY SHOT POLLY BECK HILDERBRAND, WHO JUMPED IN FRONT OF ZEKE'S GUN WHEN HE INTENDED TO SHOOT HIS BROTHER-IN-LAW. ZEKE WAS LATER PROVEN NOT GUILTY. *Collection of Jack D. Baker.*

▼ THESE ARROWHEADS ARE SIMILAR TO PROJECTILES EARLY CHEROKEES USED FOR HUNTING.

*Indian Territory was the first major step
toward Oklahoma statehood. Territorial status had been forced
on the so-called Five Civilized Tribes, and their lands, now the eastern
part of the state of Oklahoma, became Indian Territory.
What is now the western part of the state of Oklahoma
was organized as Oklahoma Territory.*

My first interest in Cherokee history was the latter days of Indian Territory. Both of my paternal grandparents had taught school in Cherokee Nation schools before Oklahoma statehood, and I can remember in my childhood hearing stories from them about those Indian Territory days. Indian Territory was the first major step toward Oklahoma statehood. Territorial status had been forced on the so-called Five Civilized Tribes, and their lands, now the eastern part of the state of Oklahoma, became Indian Territory. What is now the western part of the state of Oklahoma was organized as Oklahoma Territory. The federal court at Fort Smith, Arkansas, was given jurisdiction over Indian Territory, but its jurisdiction extended only over cases involving white people. Conversely, Cherokee courts were not allowed to involve themselves in any case in which a white person was party.

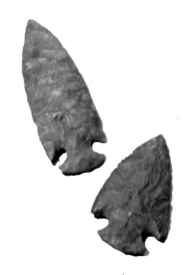

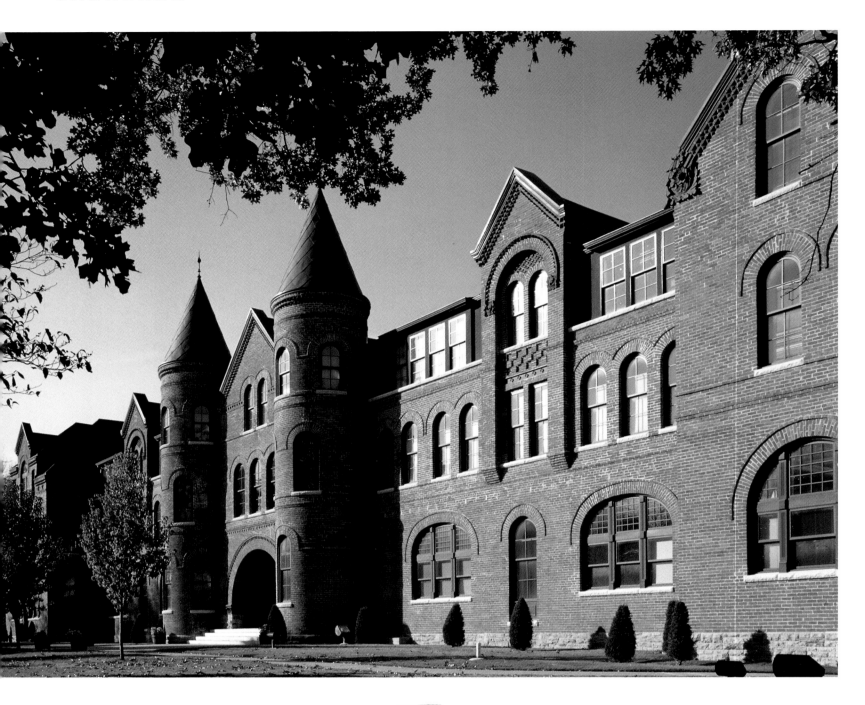

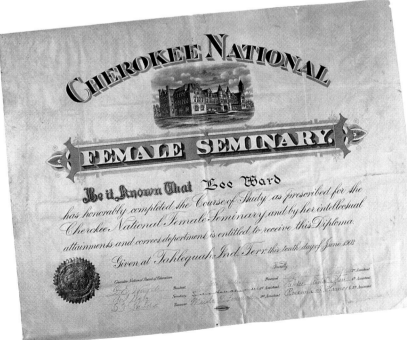

Because of this crippling jurisdictional situation, many white outlaws sought refuge in Indian Territory. The only law enforcement officers who could arrest them were the deputy U.S. marshals patrolling Indian Territory out of Fort Smith. There are tales of Jesse James and Cole Younger taking advantage of Indian Territory. Bill Doolin, the Dalton brothers, and others, not quite so well known today, operated in Indian Territory. A white woman from Missouri, Myra Belle Shirley, married a Cherokee named Sam Starr, settled in Indian Territory, and became notorious as Belle Starr.

And there were Cherokee outlaws as well: Cherokee Bill, Bill Cook, Bob Rogers, and other mixed-blood Cherokee citizens. Then there were the full-blood Cherokees who were outlaws according to the United States, but whom many Cherokees believe to have been

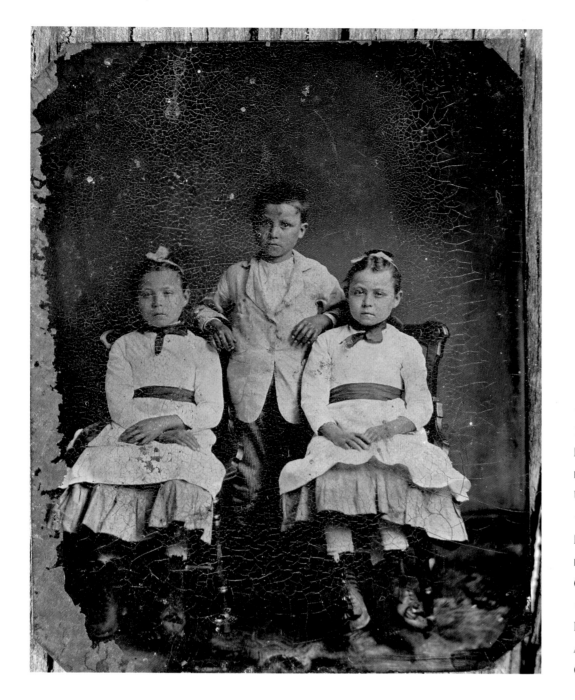

◄ ◄ SEMINARY HALL, CONSTRUCTED IN
1887–89 TO REPLACE THE CHEROKEE
NATIONAL FEMALE SEMINARY THAT
BURNED IN 1887. NORTHEASTERN STATE
UNIVERSITY, TAHLEQUAH, OKLAHOMA.
◄ ▼ DIPLOMA FROM THE CHEROKEE
NATIONAL FEMALE SEMINARY FOR A
PERSON NAMED LEE WARD, JUNE 1903.
Collection of Northeastern State University.
◄ TINTYPE OF ZEKE PROCTOR'S TRIPLETS,
LINNIE, WILLIE, AND MINNIE, BORN 1872
AND PHOTOGRAPHED C. 1880.
Collection of Jack D. Baker.

Cherokee patriots and nationalists who became victims of political persecution.
They were members of the Nighthawk Keetoowah Society, a traditional, conservative,
full-blood, nationalistic Cherokee society dedicated to the preservation of Cherokee
ways and of Cherokee sovereignty. Most notable among this group was Ned Christie.
Charlie Wickliffe, Mose Miller, and Zeke Proctor were other members. Many of these
people, or their parents or grandparents, had been Pin Indians during the Civil War.

My grandfather, Benjamin Franklin Conley, had some of Ned Christie's nephews as
students in his schoolhouse. He had seen Charlie Wickliffe and his brothers pass by
the school on a number of occasions, and he later became acquainted with Charlie's
youngest brother, Tom. My grandmother remembered the day in 1895 (she was only
five years old) when someone came to the house and told them that Zeke Proctor and
Dick Crittenden had just been killed in Wagoner. (Her father's stepfather was a
Crittenden, and she called Zeke and Dick her cousins.) They had been shot by Ed
Reed, a son of Belle Starr and a sometime outlaw and sometime lawman.

As a child, I heard my grandparents' stories about the Indian Territory outlaws, and
those tales fascinated me. I was nearing thirty years of age, though, before I realized

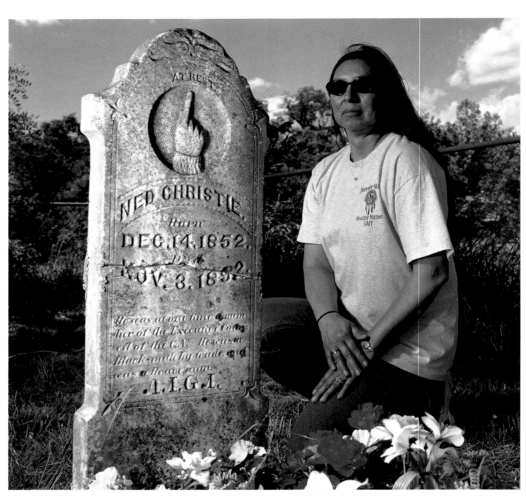

▲ Betty Christie Frogg beside the grave of her great-great-uncle Ned Christie (1852–92). Betty is director of the Twenty-First Century Learning Center, which teaches Cherokee language, culture, and history, Tahlequah, Oklahoma.

Ned Christie

Ned Christie, a full-blood Cherokee who lived a few miles from Tahlequah, was a member of the traditionalist Nighthawk Keetoowah Society. A blacksmith and a gunsmith, he was an elected member of the Cherokee Nation's Council. At a time when the Cherokee Nation had already—along with the Choctaw Nation, Chickasaw Nation, Creek Nation, and Seminole Nation—been removed to Indian Territory, and the movement toward the allotment of Indian lands and eventual statehood was becoming more obvious, he was outspoken about Cherokee rights. He was a respected citizen of the Cherokee Nation, and so his voice of resistance was heard.

In 1887, the Cherokee National Female Seminary burned, and a special Council meeting was called to deal with that event. Ned Christie went to Tahlequah for the meeting. It happened that a small posse of deputy U.S. marshals was camped just north of Tahlequah. When Dan Maples, the leader of the posse, was returning to the camp after shopping in Tahlequah, he was walking across a log footbridge that crossed the creek running between town and his camp. As he neared the north side of the creek, someone fired five shots into his back from the nearby woods. Ned Christie was accused of the murder.

A friend stopped Christie as he was making his way to the Council meeting, told him that he had been accused, and suggested that Christie get out of town. Since

Maples was not only a white man but also a deputy U.S. marshal, the U.S. District Court at Fort Smith would have jurisdiction. Judge Isaac C. Parker presided over the Court, and few Indians expected a fair deal from the "Hanging Judge." Ned Christie went home and wrote a letter to Parker declaring his innocence and asking for some time to prove it. The letter was not answered. Instead, Parker sent a posse to Christie's house.

In the fight that followed, Ned Christie's teenage son, Archie, was shot through the chest. Ned was shot in the face, the bullet breaking his nose, tearing out an eye, and traveling under the skin around to the back of his head. In spite of their severe wounds, Ned and Archie were led into the woods by Ned's wife, and they escaped the posse. Miraculously, both Christies survived.

Having lost their prey, the frustrated posse set fire to the house and burned it to the ground. They also burned Ned's blacksmith and gunsmith shop. Ned and Archie were nursed back to health and rebuilt their house, and having learned that news, the posse came back. Each time, they found Ned Christie at home. Each time, Ned drove them away. His method was to shoot a member of the posse but not kill him. That way, the others would have to take the wounded man to get medical attention.

This pattern continued for four-and-a-half years until Judge Parker assigned the case to Deputy Marshal Paden Tolbert. Tolbert recruited twenty-two men for his posse, and he loaded up a wagon with supplies, planning for a long siege of what had become known as "Ned Christie's fort." When the Christie home was rebuilt, it was constructed of double log walls with the space between the two walls filled with sand. Tolbert planned to have enough men so that if any men should be wounded, someone could take the wounded back to town without the whole posse having to abandon the siege. He took dynamite and a field cannon.

The posse surrounded the house. Ned, Archie, a neighbor named Archie Wolf, and Ned's wife were all at home. The posse fired at the house all night long. Some of the men had old-time, muzzle-loading rifles. Tolbert had them load their rifles with flaming dowel rods and fire them at the house, hoping to set it on fire. That didn't work. He had the cannon fired at the house to no effect. He had the cannon loaded with extra powder and the explosion split the barrel. At last, he had some of the men fashion a rolling shield out of an old wagon. Using the shield, they got close to the house with sticks of dynamite. When the front wall of the house was blown to bits, Ned Christie came running out through the flying debris. The others got out the back door and disappeared into the woods. The deputy who had placed the dynamite was crouching behind some brush, and as Ned ran past him, he stood up and shot Ned in the back of the head. Sam Maples, the son of Dan Maples, whose murder had started the whole thing, ran to the body and emptied his revolver into its back. When they checked the rifle Ned had been carrying, they found that it was empty.

As if to justify the fact that it had taken them more than four years to get a man who seemed to be always at home, not to mention the incredible firepower it took them to get the job done at last, the deputies, the press, and the federal court built Ned Christie into a ferocious outlaw. One writer of what Cherokee historian Emmet Starr called "six-gun history" named Ned Christie as "the worst outlaw ever to infest the Indian Territory." He went on to say that Ned had committed "numerous robberies, murders and rapes." All this in spite of the fact that Ned Christie was never charged with any crime except the murder of Dan Maples, and that charge was never proven.

NED CHRISTIE

CHEROKEE

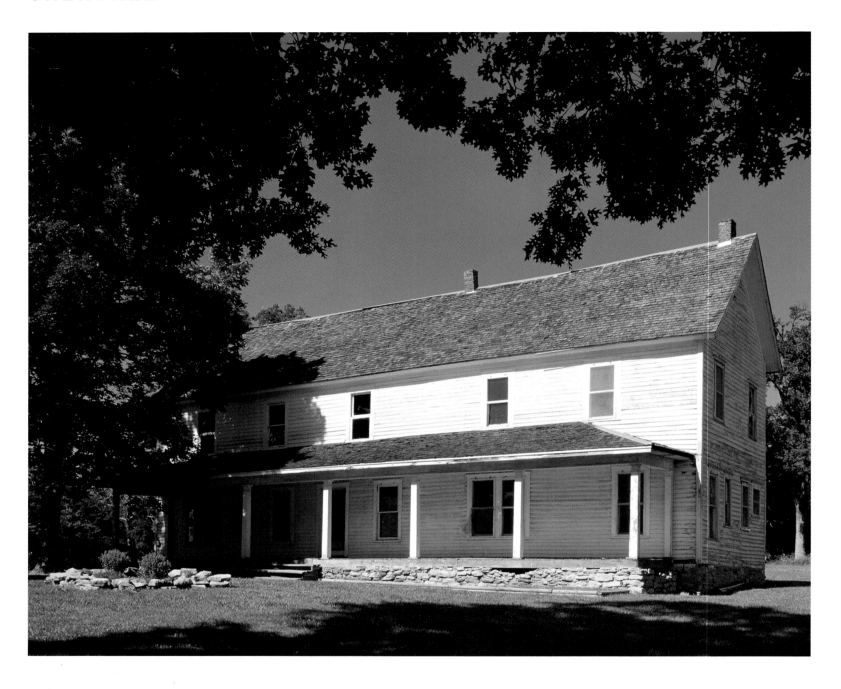

▲ THE SALINE COURTHOUSE, 1889. THIS
COURTHOUSE IS THE ONLY ONE OF NINE
ORIGINAL CHEROKEE DISTRICT COURTHOUSES,
ALL BUILT IN THE SAME YEAR, THAT IS STILL
STANDING. IT SITS OFF A ROAD MARKING THE
BOUNDARY BETWEEN DELAWARE AND MAYES
COUNTIES, OKLAHOMA.

that there were stories in print about the same men I had listened to my grandparents
talk about, and I began reading those stories wherever I could find them. I was struck,
however, by the curious fact that, in almost all the stories about the full-blood
"outlaws," very few details were given. The writers simply labeled them as outlaws
and then concentrated on the chasing of them by the deputy marshals.

My curiosity and anger regarding these omissions led to my own writing career,
and that career began with stories about Indian Territory days. I tried to show with my
fiction what I thought to be the truth about those days as opposed to the kinds of
propaganda I had been reading. Slowly, I began to delve farther back into the history
of the Cherokees. Too many Cherokees know too little of their own history, and
happily, the current administration of the Cherokee Nation is working to correct
that problem by offering courses in the communities on Cherokee history.

At any rate, Indian Territory was so lawless (because of the jurisdictional problems
created by the federal government) that the government and the media began saying
that the Cherokees were incapable of maintaining law and order. That became
the justification for imposing federal law on the Nation, a wonderful example of
circular reasoning.

▲ Fort Gibson, Oklahoma, established in 1823. Fort Gibson was the first military post in Indian Territory, and for the next half century most people, especially the Cherokees, had ties with the fort. It was reconstructed in the 1930s. Over its history, it has housed such notables as Jefferson Davis, Zachary Taylor, and Sam Houston. The fort sits where the Neosho and Verdigris Rivers join the Arkansas River on the border of Cherokee County.

The Western Cherokee Nation and the Texas Cherokees

In 1794, a group of Cherokees from the Chickamauga faction left their old homes and moved to Missouri. Historians differ on just who made up this group and on what their reasons were for making the move. The most popular story is that the group, led by Chief Bowles, got into a fight and killed some white men. Fearing retaliation from whites as well as from other Cherokees, who had recently signed a treaty, they moved west. Whatever the truth, these Cherokees were in Missouri when the great earthquake of 1811 struck. That event caused them to move again, this time into northwest Arkansas.

They were an interesting group, made up of full-blood Cherokees, mixed-blood Cherokees, and whites who had been Tories during the American Revolution. In Arkansas, they built settlements along the Arkansas and White Rivers and soon began to prosper in their new surroundings. Prominent in this group, besides Bowles, were John Jolly, who some years earlier had adopted the young Sam Houston, Degadoga (historians have called him Takatoka and Ticketoke among other things), and Captain Dutch, whose portrait was painted by George Catlin.

Almost as soon as they arrived in Arkansas, these Cherokees found themselves embroiled in a war with the Osage Indians. It was a brutal war on both sides, and the U.S. Army manning Fort Smith acted as peace broker, attempting to bring an end to the war. Officers at nearby Fort Gibson, in what is now Oklahoma, also became involved. There was a reason the United States was so interested in establishing

peace between the Cherokees and the Osages. Government agents were circulating among the Cherokees back in the eastern homelands trying to persuade them to move west and join their fellow tribesmen. The war raging out west made their task much more difficult.

In 1816, U.S. Agent William L. Lovely, attempting to calm the war, purchased from the Osages a vast amount of land in what is now northeast Oklahoma. He purchased it for the Western Cherokees to use as hunting grounds. There were no Osage villages on that land. In spite of the purchase, Cherokees and Osages continued to meet on the land known as Lovely's Purchase and get into fights.

Because the federal government was trying to persuade all Cherokees to move west, it recognized the Cherokees' rights in Arkansas, and it recognized the Cherokees there as a separate government from the Cherokee Nation, signing treaties with them as the Western Cherokee Nation. In the meantime, the war continued with Cherokee war leaders Degadoga and Captain Dutch. Both of these men were inveterate Osage haters. Degadoga called them "a nation of liars," and when U.S. Army officials told him that they wanted peace between the Cherokees and the Osages, Degadoga agreed and added that the only way to achieve that was to kill all the Osages. Dutch had some years earlier been married to an Osage woman. Her own people killed her for reasons unknown to us, and thereafter Dutch could not seem to get enough revenge.

In 1819, U.S. agents surveyed the land in Arkansas and told the Western Cherokees that they had to move their homes to locations north of the Arkansas River. Out of anger and spite, Bowles, taking a number of families with him, moved not north but south—clear into southern Spanish Texas, where they became known as the Texas Cherokees.

In spite of the unrest in Arkansas, small groups of Cherokees moved west to join the Western Cherokee Nation from time to time. In 1824, Sequoyah, who had moved west to Arkansas, presented his syllabary and had it tested in public. That same year, the U.S. Army successfully brokered a peace treaty between the Western Cherokees and the Osages. The following year, unable to accept the peace, Degadoga and Dutch moved south into Texas, not as far south as had Bowles, and built new settlements along the Red River. From there they continued to raid Osage villages all the way to where Claremore, Oklahoma, now stands. In 1825, Degadoga died, leaving Dutch the lone holdout of the war.

Because the Western Cherokee Nation had signed a treaty with the Osages under the auspices of the U.S. Army, Dutch was declared an outlaw by his own government. The U.S. Army wanted him as well. So did the Osages.

White squatters began to move into Lovely's Purchase, and Arkansas was considering creating Lovely County, Arkansas, for them. In 1828, a delegation from the Western Cherokee Nation, including Sequoyah, went to Washington, D.C., to protest. The negotiations did not go well for the Cherokees. Government officials told them that if they would all move into new homes in Lovely's Purchase, then the federal government would make the white people move out. That meant that the Western Cherokees had to abandon their homes and all claims to land in Arkansas. Rather than lose Lovely's Purchase to white settlement, they agreed.

The Western Cherokees moved the next year, and shortly after that, Sam Houston came out to rejoin his adopted Cherokee family. He had recently resigned his office as Governor of Tennessee following a scandal about his marriage. Houston was accepted

into the Western Cherokee Nation as an adopted citizen. He married a Cherokee woman named Diana Rogers and settled down to run a store. More than once, he was sent to Washington as a delegate from the Western Cherokee Nation. But at home, near Fort Gibson, he became known as the "Big Drunk."

In 1831, with the aid of Sam Houston, a final peace was made between the Western Cherokee Nation and the Osages. Part of the treaty agreed that if any Cherokees living outside the jurisdiction of the United States and of the Western Cherokee Nation within a year of the signing were to return to the Western Cherokee Nation, all would be forgiven. John Jolly, Houston's adopted father and Chief of the Western Cherokee Nation, knew that with Dutch on the loose there would be more trouble and the peace would not last. He sent some men down into Texas to bring Dutch home. Dutch made the move, and the long war was at last over. Dutch made his new home north of the Canadian River on a creek that he named Dutch's Creek. (Local people, having forgotten the history, now call it Duchess Creek.)

Houston's drinking got the best of him one night in 1832, and he beat up old John Jolly. The next morning, sober and ashamed, he packed up and left for Texas. There he made contact with Bowles and the Texas Cherokees. When the Texans rebelled against Mexico, Houston enlisted the help of the Texas Cherokees. A treaty was concluded between the Texas Cherokees and the provisional government of Texas, but following the war, the Texans turned on Houston and on the Cherokees, maintaining that the treaty was no good as the Republic of Texas had not existed when it was signed. In 1839, Texans attacked the Cherokees, who were on their way out of Texas, and killed a good many of them on the battlefield. Bowles, by then in his eighties, was killed by a shot to his head at close range. The survivors scattered. Many of them moved into the area formerly known as Lovely's Purchase. Others went to Arkansas. Some escaped into Mexico.

That same year, following the Trail of Tears, the Cherokee Nation, just removed to the area known as Lovely's Purchase, met in Council. A few miles away, the Western Cherokee Nation held its own meeting. Runners were sent back and forth until, finally, some Western Cherokees agreed to sign an Act of Union, effectively dissolving the Western Cherokee Nation and reabsorbing its population into the larger Cherokee Nation. The Western Cherokee Nation, existing from 1794 until 1839, has been largely forgotten. Today, when the people of that nation are remembered, they are usually referred to as the Cherokee Old Settlers or Early Settlers, those who came out west before the Trail of Tears.

▲ 1847 *Cherokee Almanac.*

AND THE TEXAS CHEROKEES

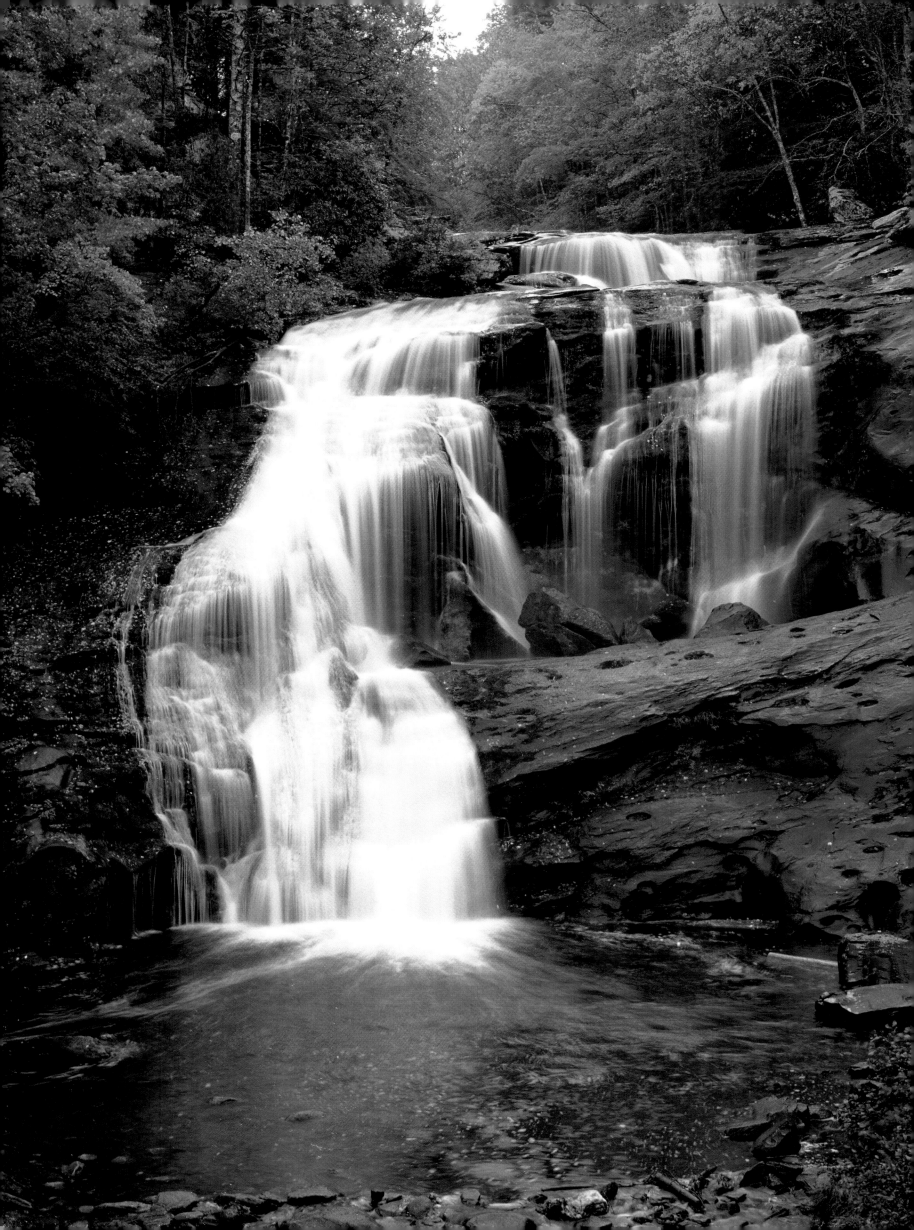

STATEHOOD

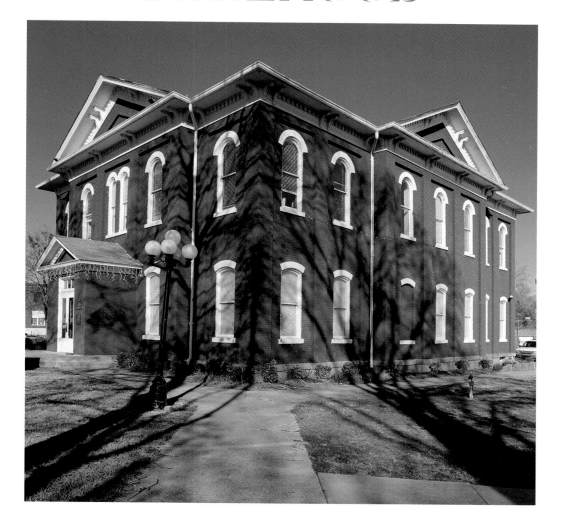

*Cherokee citizens woke up one morning
in 1907 to find themselves no longer citizens of a free
and independent Cherokee Nation, but citizens of the United States
and of the new state of Oklahoma, created by combining
the "Twin Territories" of Indian Territory
and Oklahoma Territory.*

The days of Indian Territory were numbered as soon as the Territory was established. As early as 1873, Principal Chief William Potter Ross predicted what was to come: the dissolution of the Cherokee Nation and the ultimate absorption of Cherokee people into the general population of the United States. It took another thirty-four years, but by means of a series of federal laws and actions of federal committees, Cherokee citizens woke up one morning in 1907 to find themselves no longer citizens of a free and independent Cherokee Nation, but citizens of the United States and of the new state of Oklahoma, created by combining the "Twin Territories" of Indian Territory and Oklahoma Territory. The statehood ceremony in Guthrie, the first capital of Oklahoma, included a mock wedding between a white cowboy, representing Oklahoma Territory, and an Indian "maiden," representing Indian Territory.

William C. Rogers, the last elected Principal Chief of the Cherokee Nation before statehood, was seen by the Cherokee Council as having cooperated too readily with the federal government in this statehood process. He was impeached, found guilty, and removed from office. The Council then named Frank Boudinot Principal Chief. But the federal government stepped in to reinstate Rogers. Boudinot never served.

Thereafter, the U.S. government appointed the Principal Chief of the Cherokee Nation, sometimes only for a day, now and then for a few days. He was needed only when it came time to get a legal signature on a document, almost always a deed of transfer of land. The "chiefs" thus appointed have come to be known as the "Chiefs for a Day."

Much of the business of preparing for statehood and for the imagined dissolution of the Cherokee Nation had to do with the transfer of land. Cherokees had never been individual landowners. All Cherokees owned all the land. Or, to put it in more modern governmental terms, all the land was owned by the Cherokee Nation. Individual Cherokees had the right to occupy and make use of any land not already being occupied and used, and they had the right to make use of as much land as their business required. The Cherokee Nation's land, then, at statehood, was broken up into individual allotments of 160 acres per head of household. To accomplish this purpose, enrollment officers were sent out by the Dawes Commission (named for Sen. Henry Dawes, who had proposed the General Allotment Act) to create a "final roll" of Cherokee Nation citizens. Those enrolled would receive their allotments.

The traditional Cherokees, believing that land could not be owned, were much opposed to allotment and enrollment. Many of them avoided the enrollment officers. Many of the mixed-blood Cherokee citizens, however, were eager to receive a title to 160 acres of land. Some of them might have wanted to use it for farming or ranching or some other purpose, but most of them wanted something they could lease or sell to make themselves some money. Many white people claimed to be Cherokee citizens for the same reason. Some were caught and their names stricken from the roll. Some likely got away with it, and their descendants today may be registered members of the Cherokee Nation.

And so the land was divided and allotments were assigned. Each individual Cherokee became a citizen of the United States, a citizen of the state of Oklahoma, and a private landowner. The allotted land—sometimes called trust land, Indian land, or headrights—when added together, did not constitute the whole of the old Cherokee Nation. The remaining land was declared surplus and was put to other, non-Cherokee, uses. The titles of the allotments were held in trust for the Indian owner by the U.S. government on the theory that Indians were incompetent to handle their own affairs. The land allotments were also tax-exempt.

Even though many Cherokees were opposed to allotment, once the process was complete, with the Cherokee Nation seemingly dissolved, the allotments seemed to be all that individual Cherokees had left of the old Nation, and therefore they became very dear. Some Cherokee families still live on their original allotments. Many allotments were lost through graft and corruption and for other reasons. For example, under Oklahoma law, a husband could dispose of his wife's property. My grandmother was sick and in bed for two years. My grandfather, who could not stand being in debt, signed her allotment over to the doctor to pay her bill. Some years after the death of my grandfather and many years after the deed, my grandmother said to me, "He gave away my headright. I'll never forgive him for that."

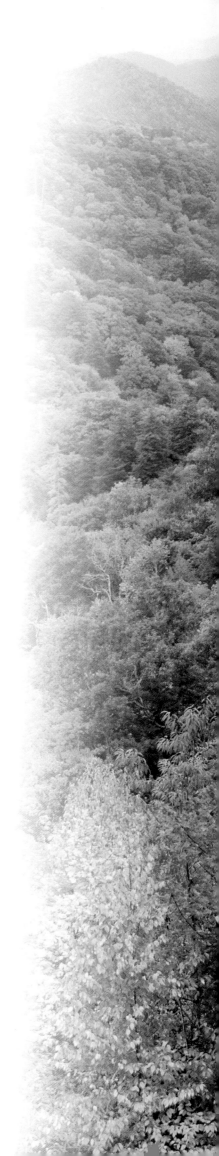

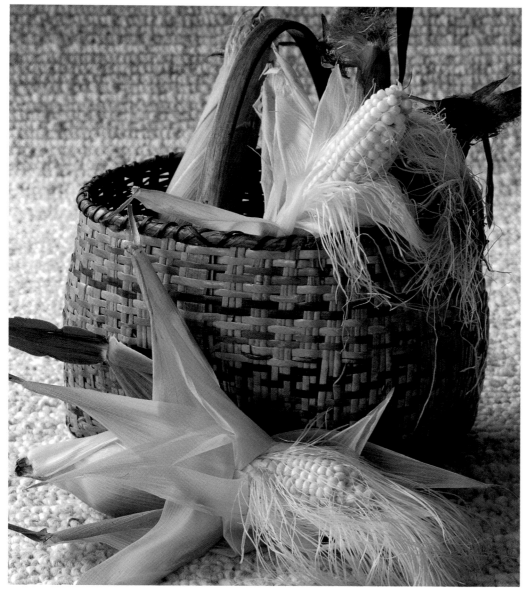

▲ Sweet corn in a 1940s Cherokee split-oak basket.
Collection of Cherokee Heritage Center, Tahlequah, Oklahoma.

Corn

Corn, or *selu*, was grown as the major crop by Cherokees long before the arrival of Europeans in America. Its significance and importance to Cherokees is illustrated in one of the origin tales from oral tradition. Kanati, the Great Hunter (First Man), and his wife, Selu, the Corn Mother (First Woman), signify the traditional Cherokee male and female roles of hunter and agriculturalist. Kanati is also identified with and sometimes personified as Thunder, and therefore the bringer of rain. Selu could produce corn and beans from her own body at any given time, but because her sons were disobedient, we now have to work and to wait to produce corn.

The Cherokees almost always produced an abundant corn crop and stored the surplus for the winter months. The British colonists quickly realized the nutritional and cultural significance of corn, and when wars broke out between the colonists and the Cherokees, the colonial militias made a point of destroying not only Cherokee towns but their accompanying cornfields, knowing the tremendous hardship that would result.

In spite of the dormancy of the Cherokee Nation, Cherokees did not cease being political. Many mixed-blood people became early Oklahoma politicians. At the same time, several grassroots, mostly full-blood, Cherokee political organizations developed. In 1938, these groups met together and elected Jesse Bartley Milam, a banker from Chelsea, Oklahoma, as Principal Chief of the Cherokee Nation. The election was not recognized by the U.S. government, of course, but in 1941, under the New Deal administration of Franklin Roosevelt, Milam was appointed Principal Chief by the President of the United States. It was the beginning of the Cherokee Nation's recovery. Technically, Milam, like the "Chiefs for a Day," was a chief appointed by the President of the United States, but he had first been elected by Cherokees.

In spite of the promise of Milam's election and appointment, some Cherokees still did not see the Cherokee Nation as a legitimate government. It had no elections, no legislative or judicial branches, and a chief executive appointed by the chief executive of another government. Because of that, a group of full-blood Cherokees organized themselves under the provisions of an act of the U.S. Congress called the Oklahoma Indian General Welfare Act of 1936, which states that any group chartered under that law will have "all the rights and privileges of any federally recognized Indian tribe." They called themselves the United Keetoowah Band of Cherokee Indians in Oklahoma, and their constitution was approved by the U.S. government in 1950. However, sometimes seemingly conflicting federal laws and the confusion resulting therefrom kept the UKB from being effective, and it remained obscure. The Bureau of Indian Affairs could not seem to make up its mind whether to deal with the Cherokee Nation or with the United Keetoowah Band.

Beginning with Oklahoma statehood, most of us simply believed that we had no more Cherokee Nation. That, it seems, was the intention of the government, and the new state of Oklahoma certainly acted as if it were the truth. The state of Oklahoma tended to ignore the great body of federal Indian law, as if there were no Indians left within its borders. In response, Cherokee people in traditional, or conservative, Cherokee communities chose to ignore the outside world as much as possible and returned to the ancient Cherokee tradition of living in autonomous towns.

Not only did Cherokee people lose their government and find themselves subjected to a government imposed on them by a foreign power, they found that the new government and its systems did not serve them well. The Cherokee Nation, by 1907, had installed the first telephones west of the Mississippi River, had built the first institutions of higher learning west of the Mississippi, and had produced more college graduates than the states of Arkansas and Texas combined. Yet sixty-three years later, the 1970 U.S. Census reported that the average adult Cherokee had but five years of school. In the 1880s, Sen. Henry Dawes had reported that there was not a single pauper in the Cherokee Nation. Yet the 1970s found a majority of the Cherokee population in northeast Oklahoma living well below the poverty level.

◄ TURN-OF-THE-CENTURY CHEROKEE LOOM WITH WEAVING SHUTTLE. CHEROKEE WEAVING CENTER, TAHLEQUAH, OKLAHOMA.
▲ CHEROKEE BASKET, 1930s. *Collection of Bacone College, Muskogee, Oklahoma.*

CHEROKEE

► WILL ROGERS'S BIRTHPLACE, KNOWN AS THE WHITE HOUSE ON THE VERDIGRIS, 1875. NO LONGER STANDING BESIDE THE VERDIGRIS RIVER, THE HOUSE WAS MOVED IN 1959 ABOUT ONE MILE WEST, TO MAKE WAY FOR LAKE OOLOGAH.

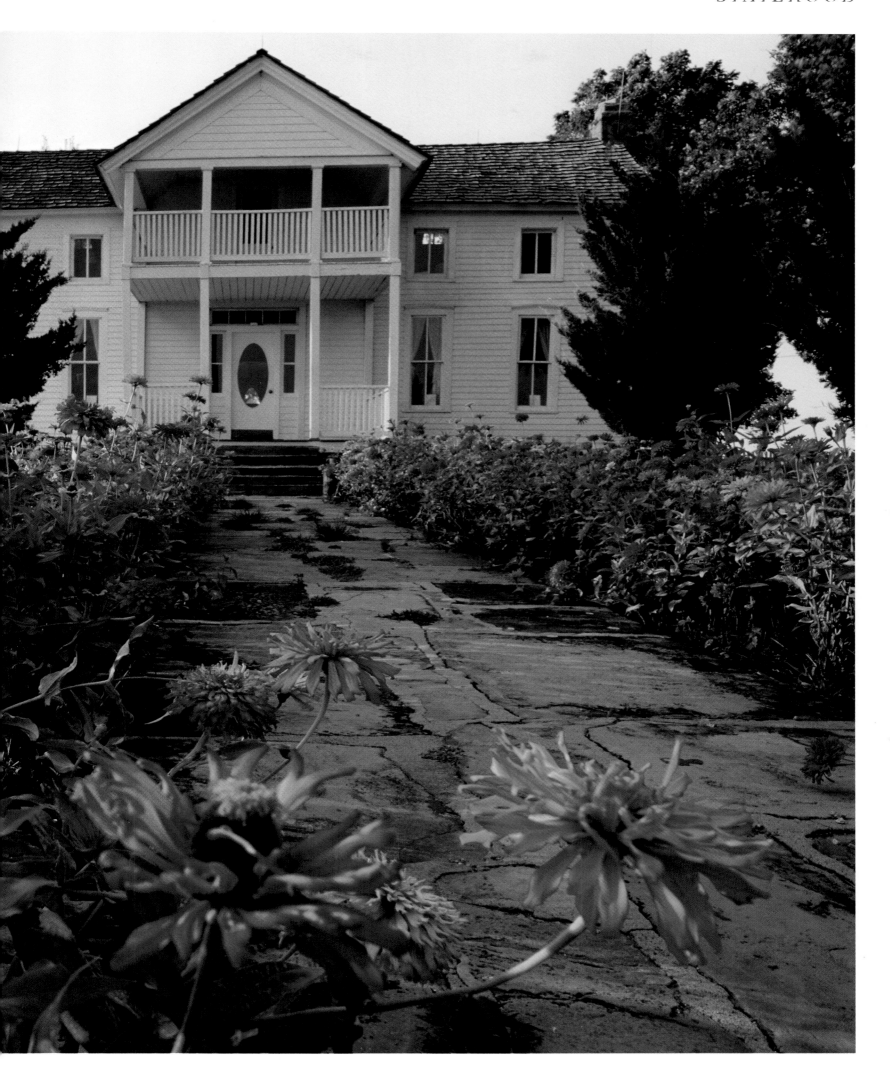

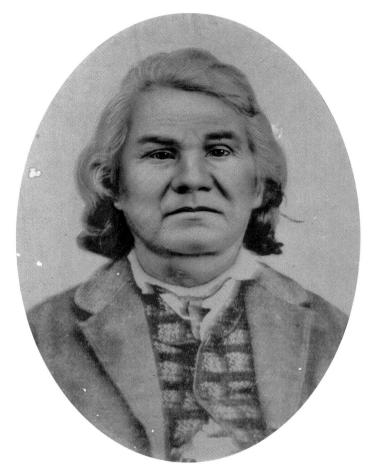

▲ GENERAL STAND WATIE.

Prominent Cherokees

There have been well-known Cherokees inside and outside Cherokee society since Cherokee-British colonial contact. There was Ama-edohi, who was known far and wide among the British, in the colonies as well as in England, as Moytoy, "Emperor of the Cherokees." Major celebrity status in those days belonged to Ada-gal'kala (Leaning Wood), nicknamed by the colonists the "Little Carpenter." He was highly respected as a diplomat. His sometime rival Agan'stat' (Groundhog Sausage) was also widely known. During the American Revolution, Tsiyu Gan'sini (Dragging Canoe) was both widely known and widely feared and hated by colonial rebels; they called him the Cherokee Dragon and the Savage Napoleon. At the same time he was highly respected by the British.

In the years following the Revolution and before the Trail of Tears in 1838–39, Principal Chief John Ross became prominent nationally. Elias Boudinot, whose Cherokee name had been Buck Watie before he took the name of a benefactor for his own, was known as a speaker and a journalist. He toured the northern United States speaking out against the coming Removal, and he was the first editor of the Cherokee Nation's newspaper, the *Cherokee Phoenix*. He also made use of Sequoyah's syllabary to become the first Native American novelist.

► ELIAS BOUDINOT'S *POOR SARAH*.

By far the best-known Cherokee of the Civil War was Confederate General Stand Watie, brother of Elias Boudinot. He was the last Confederate general to surrender.

John Rollin Ridge fled Cherokee country because of the violence following the Trail of Tears. In California, he became a celebrated journalist, poet, and novelist. His *Life and Adventures of Joaquin Murieta* is still in print today.

Perhaps the best-known Cherokee of all time is the great Will Rogers. Born on his father's ranch near Claremore, Indian Territory, in 1879, he became a world-famous and much loved humorist, but his humor often had an underlying biting wit. He began his career as a performer in a Wild West show, moved to the stage in New York, and on into movies. He also had a radio show and wrote a daily syndicated newspaper column. He was killed in a plane crash in 1935.

Other Cherokee film actors include Victor Daniels (screen name Chief Thundercloud), who was the first movie Tonto in *The Lone Ranger* and who starred in a 1939 *Geronimo;* Clu Gulager; Dennis Weaver; and most recently, the critically acclaimed Wes Studi.

Clem McSpadden is a nationally known rodeo announcer. Joe Thornton was a world champion archer. Sonny Sixkiller achieved prominence as quarterback at the University of Washington. Wilson Vann is one of the best-known and most loved and respected members of the national martial arts community. In his seventies, he still runs his own martial arts school in Tahlequah.

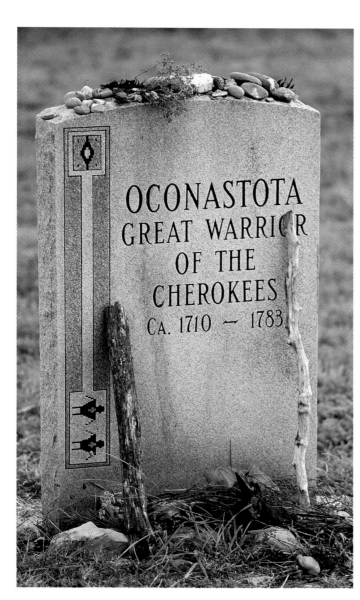

Principal Chiefs W. W. Keeler, Ross Swimmer, Wilma Mankiller, and Chad Smith are all nationally known. Mankiller especially became a major celebrity during her tenure as Principal Chief.

John Oskison was a successful novelist in the 1920s and 1930s with *Wild Harvest, Black Jack Davie,* and *Brothers Three.* Lynn Riggs, from Claremore, was a prominent playwright of that same period. His plays are mostly forgotten today, but the musical adaptation of his *Green Grow the Lilacs* continues on as the popular Rogers and Hammerstein musical *Oklahoma.*

▲ MEMORIAL TO PRINCIPAL CHIEF OCONOSTOTA (*AGAN'STAT*).

THE ROAD BACK

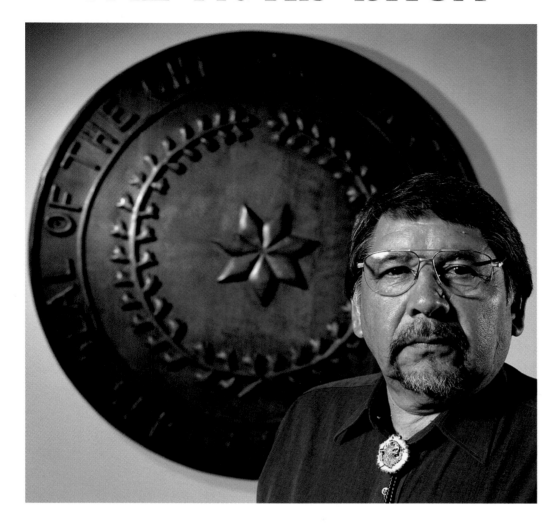

*The President of the United States, when he found it
necessary, could appoint a Principal Chief of the Cherokee Nation
just long enough to sign the land transfer documents that were needed.
That in itself constituted continued recognition of the Cherokee Nation.
This practice continued until President Roosevelt's appointment of
Milam to the position of Principal Chief of the Cherokee Nation.*

But statehood had not destroyed the Cherokee Nation. It remained a legal
government, although with almost no powers. The President of the United States,
when he found it necessary, could appoint a Principal Chief of the Cherokee Nation
just long enough to sign the land transfer documents that were needed. That in itself
constituted continued recognition of the Cherokee Nation. This practice continued
until President Roosevelt's appointment of Milam to the position of Principal Chief of
the Cherokee Nation.

Milam stayed in office and took the position seriously. He worked tirelessly for the
Cherokee People for the rest of his life. A number of Cherokee families had been
displaced to make room for the U.S. Army's Camp Gruber, and getting that land back
was one of Milam's main preoccupations. It never happened, but he tried. He was also

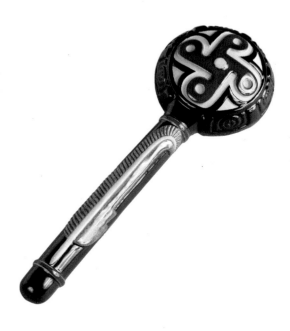

much concerned with language studies and was able to get a few Cherokee language courses established in different schools. In the area of general cultural preservation, Milam envisioned a Cherokee heritage center that would include a museum and archives. He also planned new government offices for the Cherokee Nation. He organized and financed a trip to Mexico to search for the burial place of the great Sequoyah.

When Milam died, many of his goals for the Cherokee Nation had not yet been achieved. He was replaced by President Truman's appointee, W. W. Keeler, who pursued many of Milam's plans. Keeler was an appointed chief until President Nixon caused the U.S. government to once again recognize Cherokee Nation elections. Keeler was then elected Principal Chief for one term of four years. Keeler, an executive with Phillips Petroleum Corporation, was a part-time Chief. Even so, under his administration, the Cherokee National Historical Society was formed, and the Cherokee Heritage Center was built in 1963. The Heritage Center thrives today, and it includes a museum and archives, as well as an outdoor amphitheater. Keeler also had the first new tribal office buildings built just outside of Tahlequah.

Keeler was followed by Republican lawyer and banker Ross Swimmer, who remained in office for ten years, resigning in the middle of his third term to accept the position of Undersecretary of Interior for Indian Affairs (head of the Bureau of Indian Affairs). During the Swimmer administration, the tribal office buildings, now known as the "tribal complex," were expanded to keep up with the proliferation of service programs operated by the Cherokee Nation.

► ROSS SWIMMER, PRINCIPAL CHIEF OF THE CHEROKEE NATION, AUGUST 1975–DECEMBER 1985.

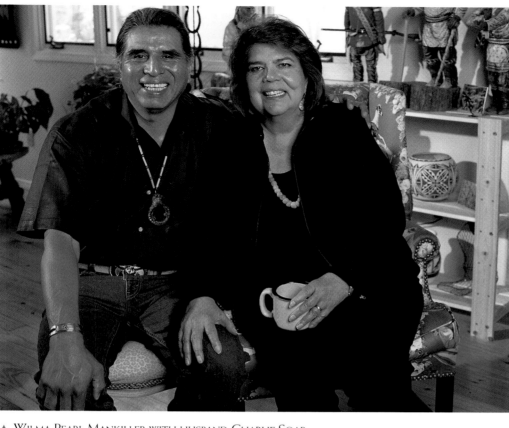

▲ Wilma Pearl Mankiller with husband Charlie Soap.

Wilma P. Mankiller

As the first, and so far only, woman Principal Chief of the Cherokee Nation, the largest American Indian tribe in the United States, Wilma Pearl Mankiller has become a worldwide celebrity. Born in 1945 on her family allotment at Mankiller Flats in Adair County, Oklahoma, Mankiller was "relocated" at the age of ten with the rest of her immediate family to San Francisco, California. She became an active participant in the political protests of 1969 with the AIM occupation of Alcatraz Island and worked for American Indian causes in California before returning home to the Cherokee Nation in 1976.

Mankiller became active in Cherokee Nation politics and worked in the area of community planning. In 1979, she was involved in a terrible traffic accident and suffered massive injuries. After a year spent recovering, she was diagnosed with a life-threatening disease, but that didn't stop her. In 1983, she was elected Deputy Principal Chief of the Cherokee Nation, and in 1985, when Chief Ross Swimmer resigned, she became Principal Chief. She was elected Principal Chief in 1987. Health problems continued to plague Mankiller, and in 1990, she underwent a kidney transplant. It seems, though, that nothing can slow her down for long. In 1991, Mankiller was elected Principal Chief again, thus serving in that office for ten years. During that time, the Cherokee Nation made great strides in many areas. No longer Chief, Mankiller continues to be active in politics, but she has also pursued a career as a writer. She published poems and short stories in the 1970s and '80s. Her autobiography, *Mankiller: A Chief and Her People,* written with Oklahoma author Michael Wallis, was published in 1993. She is currently at work on a novel and on a nonfiction book about Native American women.

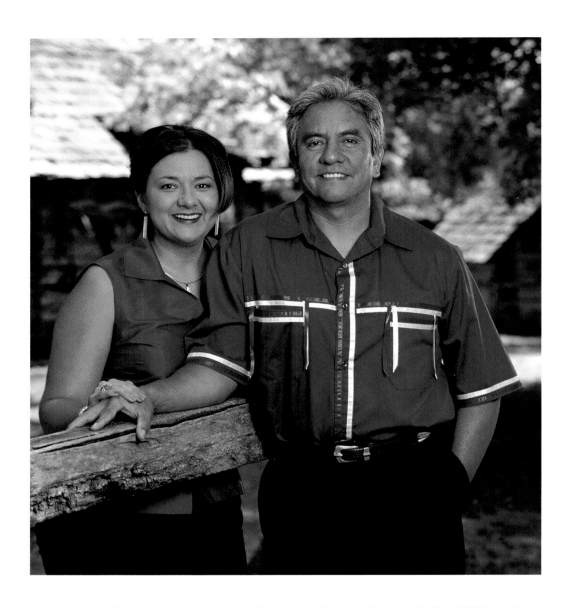

JOE BYRD AND WIFE, SUZY, AT ADAMS CORNER, CHEROKEE HERITAGE CENTER, TAHLEQUAH, OKLAHOMA. JOE BYRD SERVED AS PRINCIPAL CHIEF OF THE CHEROKEE NATION FROM 1995 TO 1999. HE WAS THE FIRST CHIEF IN MANY YEARS WHO WAS A FULL-BLOOD CHEROKEE AND BILINGUAL. HIS FATHER WAS STAND WATIE BYRD.

Following his resignation in 1985, Swimmer's Deputy Principal Chief, Wilma P. Mankiller, became Principal Chief, the first, and so far the only, woman to hold that post. Chief Mankiller served out Swimmer's final term and won her own election twice, in 1987 and 1991, serving a total of ten years. During that time, she became one of the best-known women in the world and brought much positive publicity to the Cherokee Nation. The Nation's programs, enterprises, and tribal registration continued to grow.

Beginning with the appointment of Chief Milam, the Cherokee Nation began a process of reversing the losses of the past. Through the terms of Principal Chiefs Keeler, Swimmer, and Mankiller, that process continued. The Cherokee Nation moved from a nation with almost no powers to one with its own active court system, marshals, elections, updated constitution, and many service programs and business enterprises. It moved from a nation that was almost universally believed to have been "terminated" to one that was once again at the forefront of national Indian affairs.

When Principal Chief Mankiller decided not to run for reelection in 1995, Joe Byrd became Chief by a bizarre series of events. The election had taken place, with the top three vote getters being George Bearpaw, a longtime tribal employee in the accounting department; Joe Byrd, a high-school coach and Cherokee Nation Council member; and Chad Smith, a former tribal planner and tribal prosecutor. No one received the required 51 percent of the votes, so a run-off election was scheduled between Bearpaw and Byrd. Bearpaw was suddenly discovered to be ineligible. The dilemma was presented to the Cherokee Nation's Judicial Appeals Tribunal (Supreme

Court), and they decided that the run-off ballots would go out as prepared, but that no votes for Bearpaw would count. In other words, Byrd became Principal Chief by default. The next four years were a constant turmoil, brought to national attention when Byrd defied the Cherokee Constitution and the Cherokee Court. He fired the entire marshal service and hired his own security guards. He called on the Bureau of Indian Affairs for help, and without investigating the situation, the BIA sent its police to form a protective barrier between Byrd and the legitimate Cherokee Nation Judicial System.

All the positive publicity of the past several years was nearly shattered when Byrd's security guards, reinforced by BIA police, Tahlequah city police, sheriff's deputies from three counties, and state highway patrolmen clashed with the fired marshals and Cherokee civilians on the back porch of the capitol. The melee was well covered by the media. Once again, people were saying the Cherokees could not manage their own affairs. Once again, the real fault was the federal government's. Things remained unchanged until the next election, and might not have changed even then, had not personnel from The Carter Center come to the Cherokee Nation to monitor the election.

◀ PRINCIPAL CHIEF CHADWICK SMITH WAS ELECTED IN 1999.

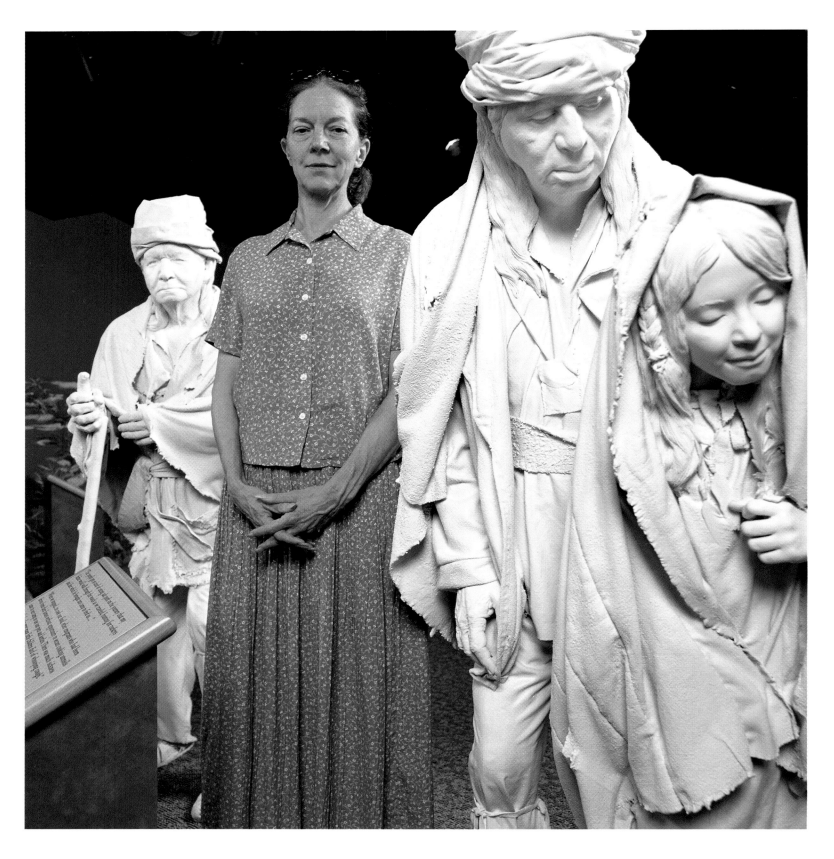

▲ Mary Ellen Meredith, Interim Director, Cherokee Heritage Center, Tahlequah, Oklahoma.

Chad Smith became Principal Chief in 1999, handily defeating Byrd. The new Deputy Principal Chief is Hastings Shade. The new administration started immediately repairing the damage done by the previous administration and implementing new policies and programs. Once again, the Cherokee Nation is moving forward.

The Cherokee Nation today is large and diverse. The boundaries of the Cherokee Nation are what they were before Oklahoma statehood, although Cherokee Nation jurisdiction applies only where land is defined as "Indian Country." That includes land owned by the Cherokee Nation and property owned by individual Cherokees that is still held in trust by the federal government. The current population of the Cherokee

Nation—that is registered tribal members—is in excess of 200,000, making the Cherokee Nation the largest federally recognized Indian tribe in the United States. Although many Cherokees still live in the Cherokee Nation, much of the population is scattered around the world. There are organized Cherokee communities in California, New Mexico, Kansas, Texas, and elsewhere. The government of the Cherokee Nation is in touch with those communities. And there are individual Cherokee tribal members, relocated for employment purposes and other reasons, virtually everywhere.

The Cherokee Nation is making a strong recovery, and though there is still much to be done, Cherokees are up to the challenge. As Principal Chief Chad Smith has said, "We are a people who face adversity, survive, adapt, prosper, and excel."

▼ VARIOUS CONTEMPORARY CHEROKEE HANDCRAFTED ITEMS—INCLUDING RATTLES, BASKETS, ARROWHEADS, CARVINGS, MASKS, JEWELRY, BEADED BAGS, DOLLS, CLOTHING, POTTERY, AND KNIVES—MADE WITH TRADITIONAL CHEROKEE TECHNIQUES AND MATERIALS. AVAILABLE FOR PURCHASE AT THE CHEROKEE HERITAGE CENTER, TAHLEQUAH, OKLAHOMA.

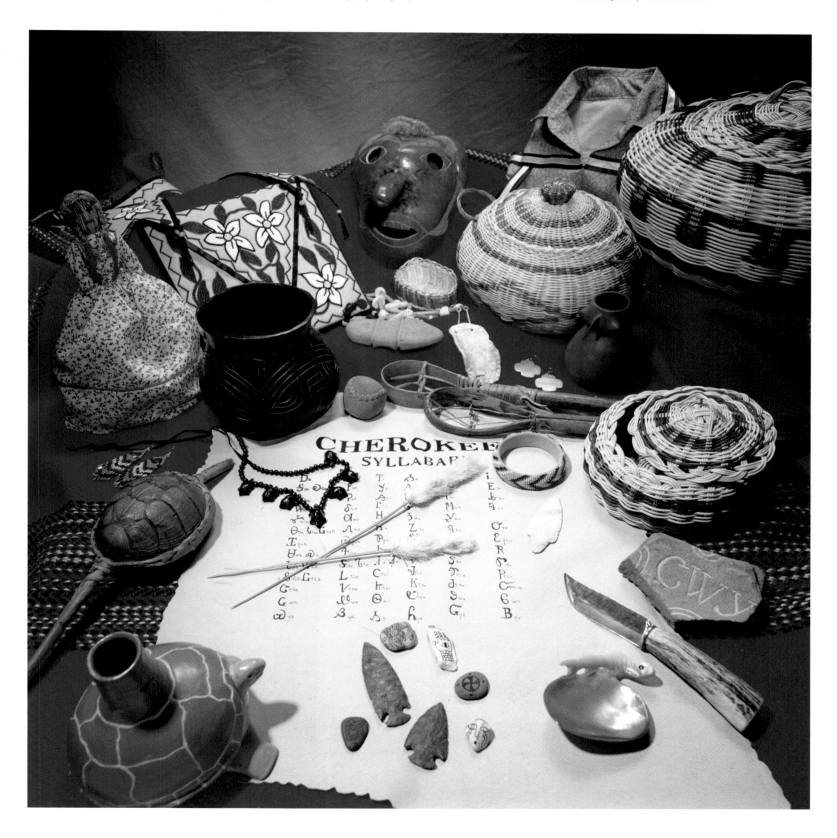

CHEROKEE PORTRAITS

Dennis Jay Hannah. Descendant of Nancy Ward and great-great grandson of Ezekial Eugene Starr.

Brad Carson. Member of Congress, 2nd District, Oklahoma.

Lauren Nicole Grayson.

Lauren is a full-blood Cherokee.

Maggie (Birdtail) McElhaney.

Eighty-five years old, mother of sixteen children.

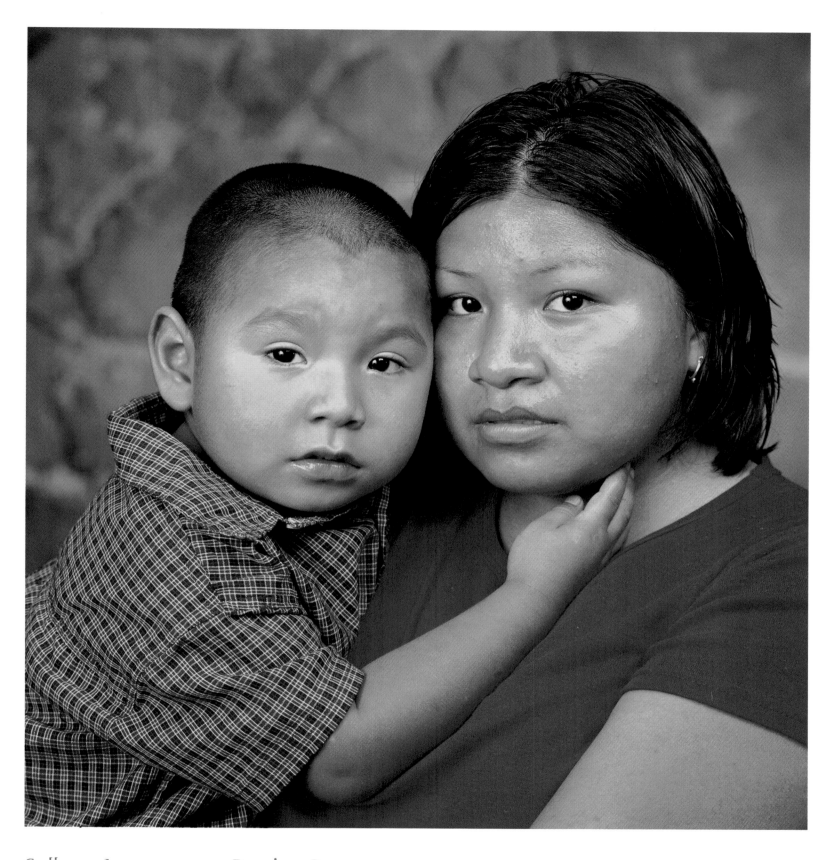

Colleen Jumper and son, Damian Beaver. Colleen is a full-blood Cherokee. Her maternal grandfather was Joe Grayson Sr., council member, and her paternal grandfather was Cherokee storyteller Willie Jumper Sr.

Boss Cummings. Chief of R.O.C. Ceremonial Grounds, Cummings is a veteran of the U.S. Army 9th Infantry and served in the Vietnam Mekong Delta.

Henry C. Smoke. An artist for more than thirty years, Smoke makes turtle-shell rattles, shackles, and pipes. His artistic inspirations are derived from his dreams.

Lorene Drywater. Lorene Drywater makes traditional Cherokee buffalo-grass dolls.

Principal Chief Chadwick Smith with his wife, **Bobbie Gail Smith**.

Melissa Bolin. A Cherokee student at Northeastern State University. Bolin is wearing the traditional Cherokee "tear" dress.

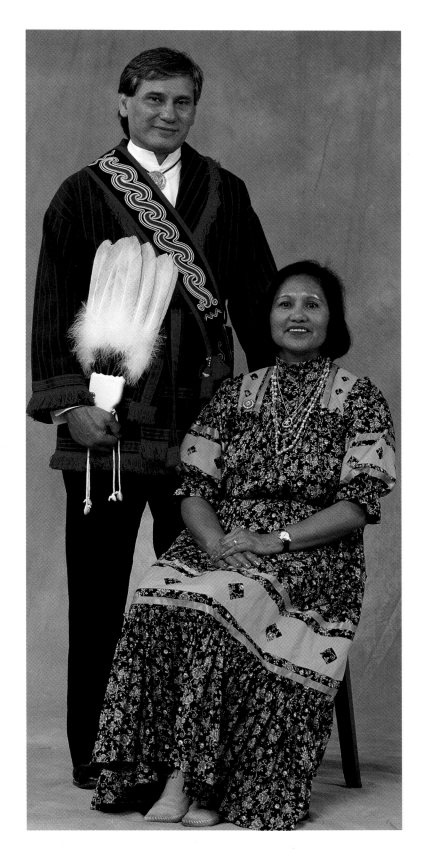

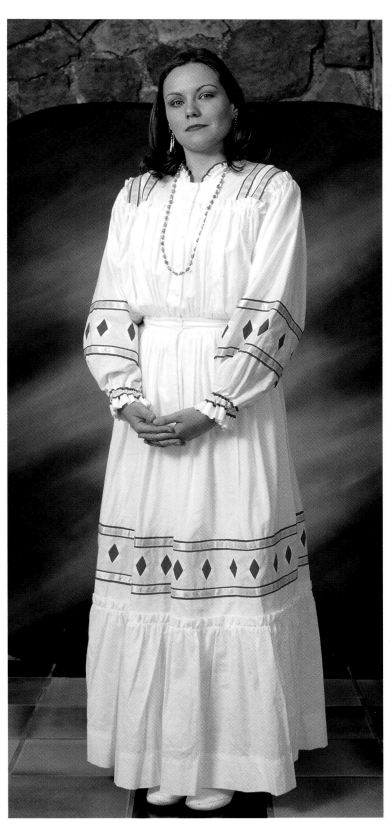

Robert Cain. Robert Cain carves "Booger Masks," which were originally used by the Cherokee to make fun of their enemies.
He uses only natural dyes and materials and traditional Southeastern woodland motifs and designs.

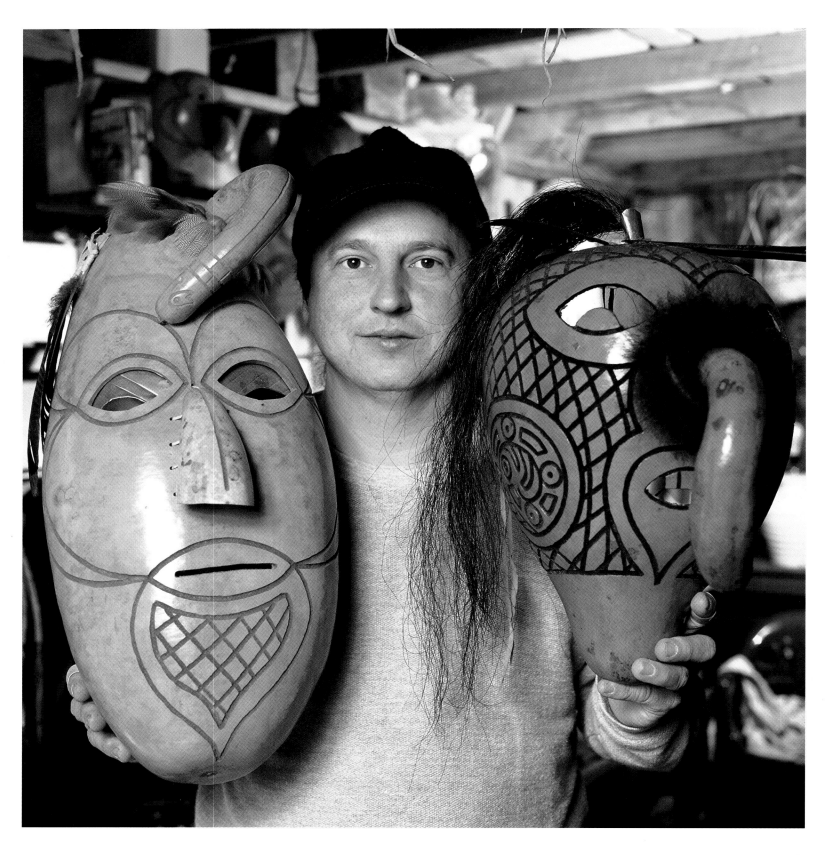

Firedancers. Left to right: Forrest Blackbear, Paul David Sellers, and George Grimmett Jr.

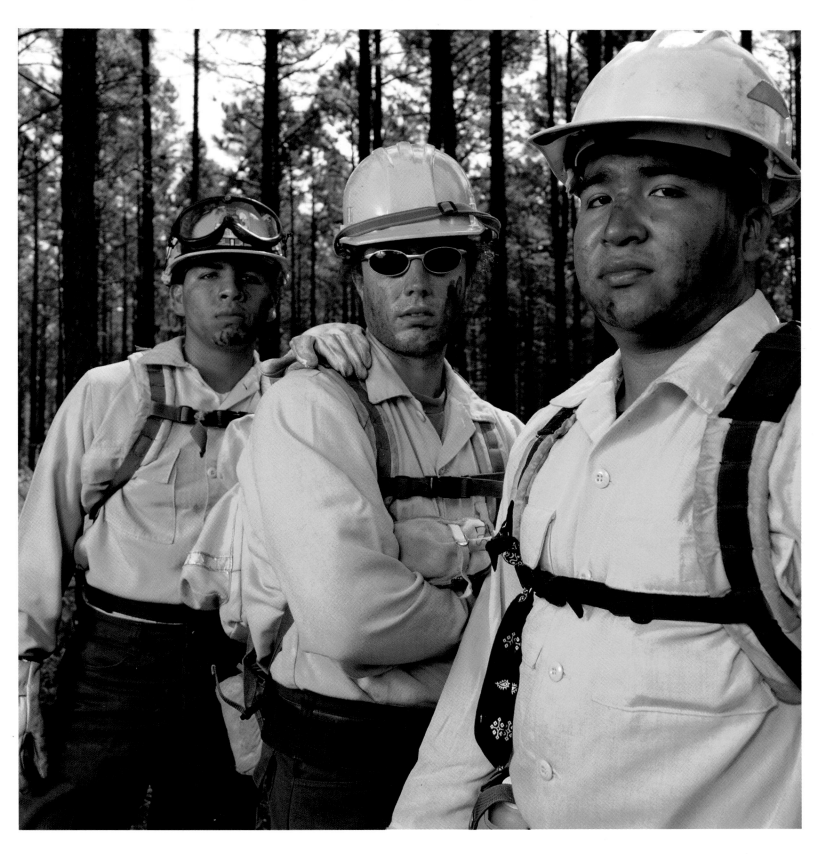

Brooks Henson. Artist Brooks Henson is known for his skills in acrylics and pencil.

His inspiration comes from a variety of sources including Cherokee legends.

Virginia Stroud. Contemporary Native American artist.

Jesse Vann.

Descendant of Joseph "Rich Joe" Vann. Born December 5, 1911, he served as crew chief for American Airlines.

The Rev.
John Goodrich.

A full-blood Cherokee, Goodrich is standing in front of the Cherokee Chapel on the grounds of Sequoyah High School in Tahlequah. His ministry is part of a seven-county association of fifty-two small churches affiliated with the Southern Baptist Convention. His paternal grandfather, Mr. Liver, fought in the Civil War.

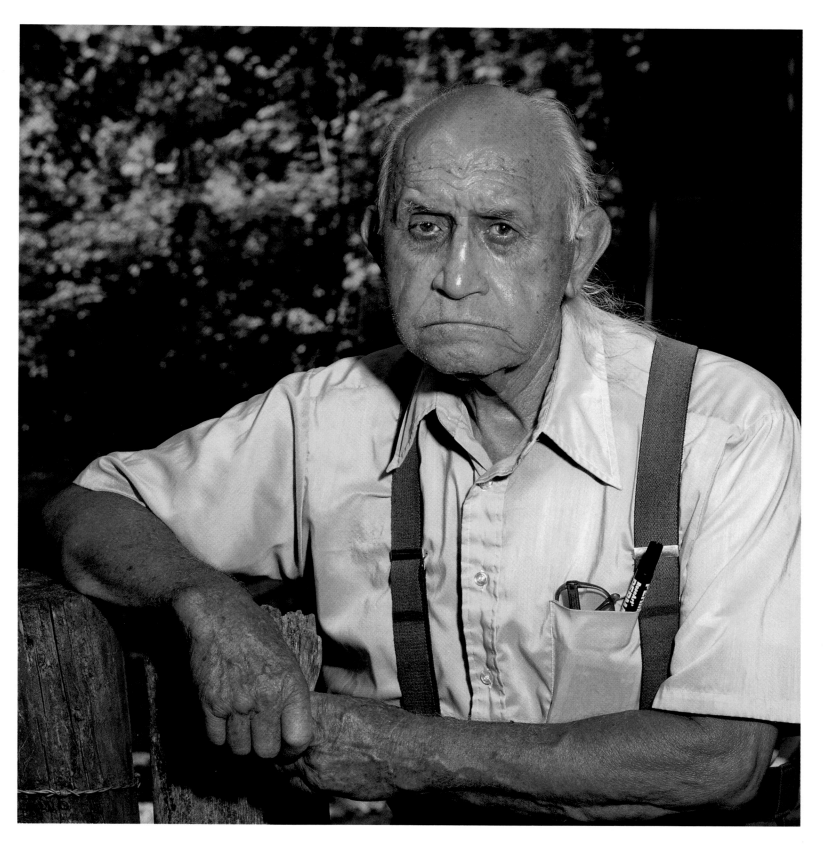

George V. Pumpkin. A full-blood eighty-one-year-old Cherokee elder, Pumpkin lives near Pumpkin Hollow.

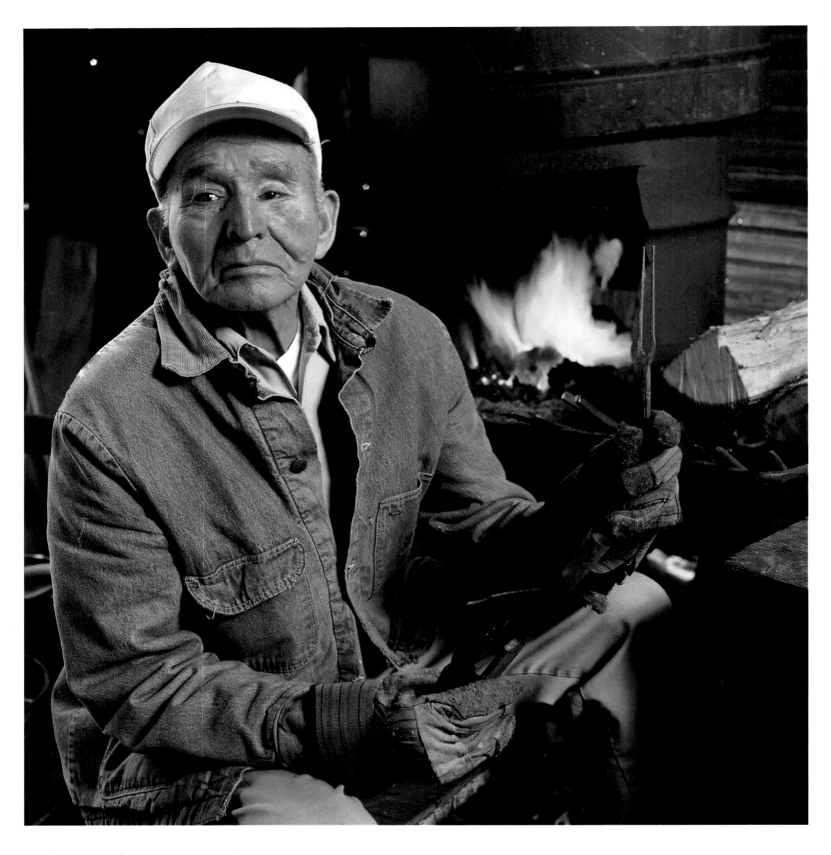

Todum Hair. A traditional Cherokee blacksmith, Hair was named a Cherokee
Nation Living Treasure for his exceptional ability to make traditional fishing gigs.

Clarence Downing. Designated Master Artist in 1974, he stands with his carved walnut bust of Sequoyah.

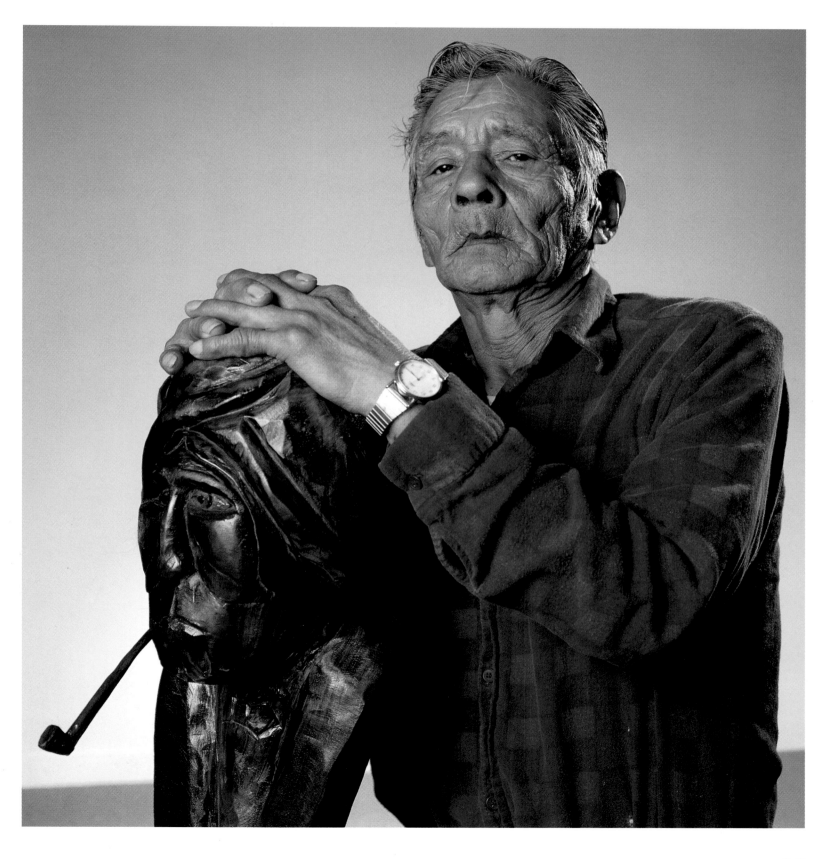

Monica Feathers. She is working on her master's degree in medicine at the University of Oklahoma
Health Sciences Center.

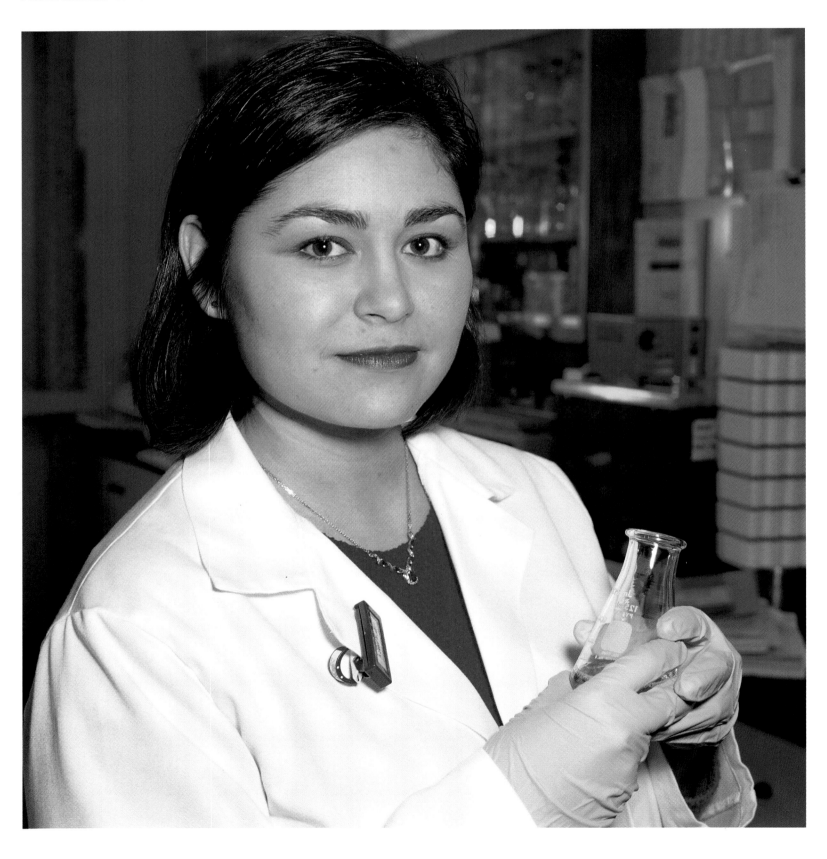

Cherokee Ballard. Ballard has been a television news anchor for KOCO television, an ABC affiliate in Oklahoma City, for eleven years. She is the only Native American anchor in the United States.

Dora Grayson. A full-blood Cherokee, she is holding a large bowl of possum grapes (*Uninasuga'*).
During illness as a child she was treated by the elders with herbs and plants. She considers herself a traditionalist.

Fred Bradley. Bradley, a Cherokee/Choctaw, recites stories of Native American folklore to groups touring
New Echota, near Calhoun, Georgia. During performances he dresses in traditional Cherokee clothing.

John Scuggin. A full-blood Cherokee, Scuggin is a descendant of Chief Dennis Wolf Bushyhead. He is a member of the Wolf Clan.

Wes Studi. A noted actor in such films as *The Last of the Mohicans*, *Geronimo*, and *Dances with Wolves*, Studi also is an expert horse trainer, author of two children's books, and an accomplished sculptor.

Bill Glass Jr. Glass is an artist in ceramic sculpture and pottery, stone carving, and bronze.
He strives to combine traditional and contemporary techniques.

Anna Bell Sixkiller Mitchell. Designated a Cherokee Nation Living Treasure, she is a master in the art of pottery. She accidentally discovered clay typical of that used by early Cherokees. Since then, she has won numerous awards and her work has been shown in many galleries and museums across the United States.

Ben Duck. Ben Duck sits with his mawl made from hickory and the pestle made from red oak, which he uses to grind hickory nuts for his famous *kenutchie*. He is also a Cherokee gospel singer and speaks Cherokee fluently. His grandmother came over the Trail of Tears.

The Rev. Woodrow Ross. Ross sits in the new sanctuary of the Emanuel Baptist Church in Kenwood, Oklahoma. Holding a Cherokee language Bible, the Rev. Ross was ordained as a Baptist minister in 1978. All of his congregation are Cherokees.

Howard Downing. Downing, eighty-one years old, lived on and farmed his fifty acres of allotted land.

Shawna Morton Cain. Cain weaves traditional Cherokee baskets by a stream where the water keeps the strands soft and pliable. She gathers her materials during various cycles of the moon and makes her dyes only from natural vegetation and grasses. She learned how to split cane in the traditional way from George Pumpkin, her husband, Roger Cain's, grandfather.

Larry E. Adair.

Speaker of the House, District 86.
Adair has been a member of the
House of Representatives, 39th
Legislature, from 1983 to the present.

Philip Viles Jr.

Viles Jr., grandson of J. Bartley Milam,
has served the Cherokee Nation as a
justice on the Judicial Appeals Tribunal
in Tahlequah, Oklahoma.

John A. Ketcher. Ketcher served as Deputy Principal Chief of the Cherokee Nation from 1985 to 1995. He is a master weaver.

Lawrence Reed. Wearing a traditional men's ribbon shirt, Reed shows how basket handles were once carved in demonstrations at Oconaluftee Village, Cherokee, North Carolina. At left is full-blood Sonny Ledford.

Velma Lossiah. Velma, a full-blood Cherokee, has been creating traditional Cherokee beadwork since she was ten years old.

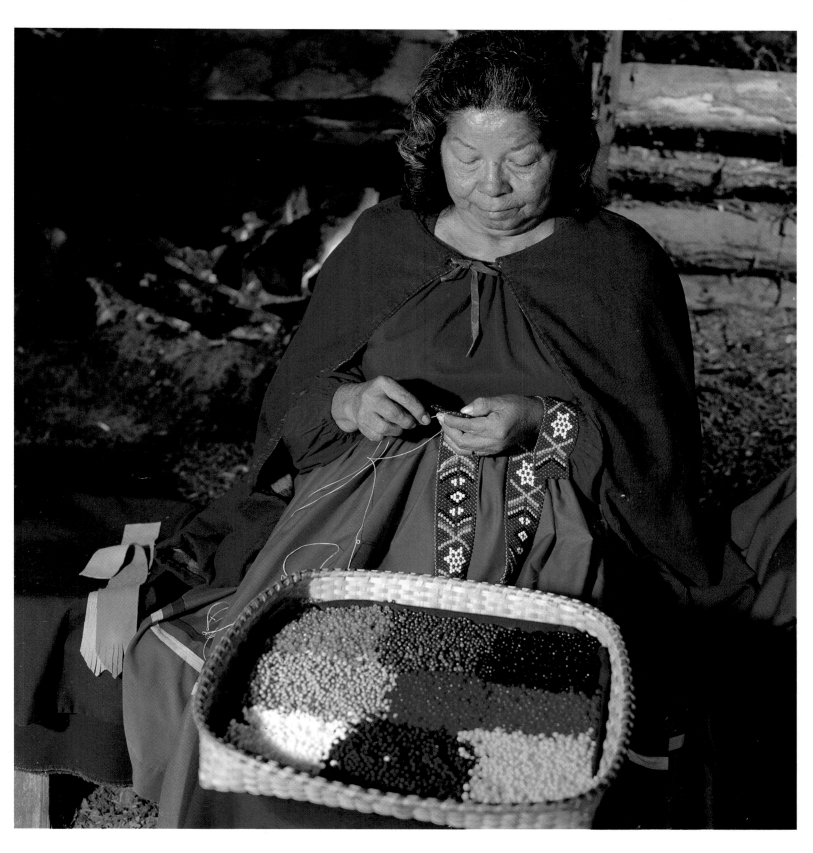

Wilson Vann. Vann holds a 6th-degree black belt in tae kwon do as well as a black belt in Kodokan judo. He has been practicing martial arts for thirty years and has won numerous trophies and medals. His ancestors can be traced back to the original Vanns of Georgia.

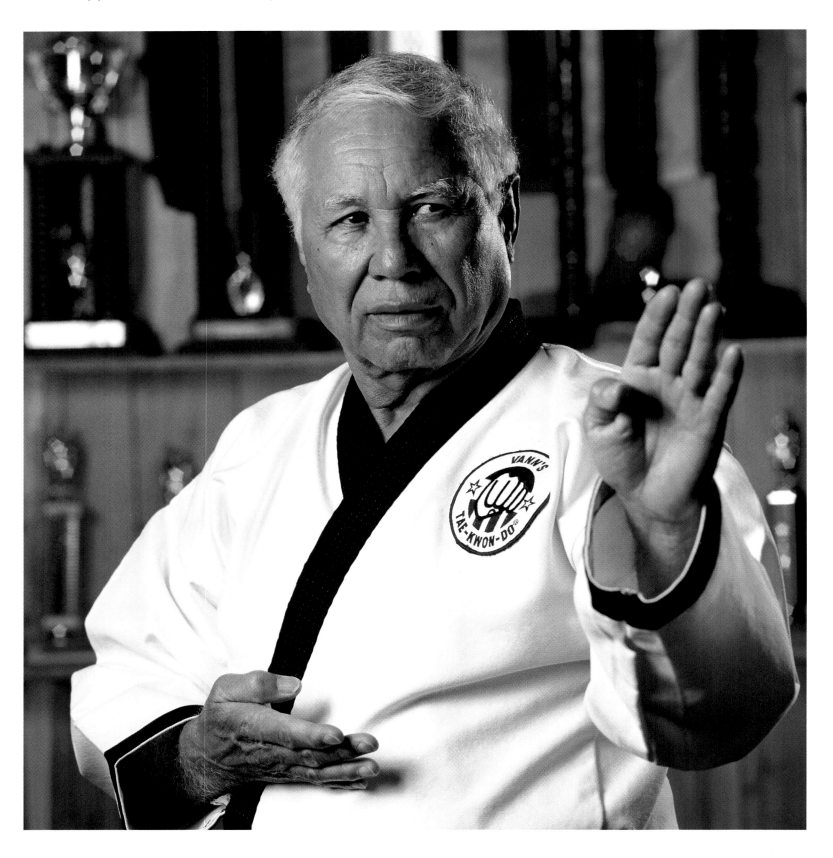

Mike Dawes. Marshal for the Cherokee Nation, Dawes is the grandson of Callie Christie, descendant of Ned Christie.

Brandon Keen.

Brandon is five years old. He and his mother, Barbara Keen, are direct descendants of Ned Christie.

Noel T. Grayson. Grayson made the bow from *boise d'arc* wood, the arrow shafts from river cane, and the feathers are from a wild turkey. Here he takes aim during the Corn Stalk Shoot on the grounds of the Cherokee Heritage Center, Oklahoma.

Knokovtee William Scott. Scott has been using shells in his traditional Cherokee jewelry since 1975. Each shell takes many hours of work to cut, grind to shape, hand sand, drill, and finally polish to a high luster. He holds a shell gorget of the ancient style.

John Guthrie. Artist Guthrie works in watercolor, acrylic, gouache, and handmade papers. He has won countless awards across the United States.

P. J. Gilliam Stewart. Stewart blends contemporary ideas with traditional methods and designs in her pottery.

MaryAnn Rich and **Natasha Money.** These finger weavers now use commercial materials instead of traditional fibers.

Marie Annie Proctor. This quilter speaks Cherokee fluently. She also makes buckbrush baskets.

Bessie Russell. Russell was designated Master Craftswoman in basket weaving in 1999 by Principal Chief Chad Smith. She gathers all her materials, such as cane and honeysuckle, and material for dyes such as black walnut, blood root, and buckbrush.

Eunice O'Field. O'Field was born and raised in Kenwood, Oklahoma. She has been recognized as a National Treasure/Master Craftsperson for her expertise in weaving and basket-making.

Yvonne Davis. Davis is a retired teacher. Great-granddaughter of Chief John Ross, she is standing in front of the Murrell Home built in 1845 by George M. Murrell.

Bibliography

Abel, Annie Heloise. *The American Indian and the End of the Confederacy*. Lincoln: University of Nebraska Press, 1993.

Collier, Peter. *When Shall They Rest? The Cherokees' Long Struggle With America*. New York: Holt, Rinehart and Winston, 1973.

Cotterill, R. S. *The Southern Indians: The Story of the Civilized Tribes Before Removal*. Norman: University of Oklahoma Press, 1954.

Crow, Vernon H. *Storm in the Mountains: Thomas' Confederate Legion of Cherokee Indians and Mountaineers*. Cherokee, North Carolina: Museum of the Cherokee Indian Press, 1982.

Cunningham, Frank. *General Stand Watie's Confederate Indians*. Norman: University of Oklahoma Press, 1998.

Ehle, John. *Trail of Tears: The Rise and Fall of the Cherokee Nation*. New York: Anchor Books, 1989.

Finger, John R. *Cherokee Americans: The Eastern Band of Cherokees in the Twentieth Century*. Lincoln: University of Nebraska Press, 1991.

Fogelson, Raymond D. *The Cherokees: A Critical Bibliography*. Bloomington: Indiana University Press, 1978.

Foreman, Grant. *Indian Removal: The Emigration of the Five Civilized Tribes of Indians*. Foreword by Angie Debo. Norman: University of Oklahoma Press, 1972.

Gregory, Jack, and Rennard Strickland. *Sam Houston with the Cherokees: 1829–1833*. 1967. Reprint, Norman: University of Oklahoma Press, 1996.

Hatley, Tom. *The Dividing Paths: Cherokees and South Carolinians through the Revolutionary Era*. Oxford, United Kingdom: Oxford University Press, 1995.

Hoig, Stan. *Sequoyah: The Cherokee Genius*. Oklahoma City: Oklahoma Historical Society, 1995.

Mankiller, Wilma, and Michael Wallis. *Mankiller: A Chief and Her People, An Autobiography by the Principal Chief of the Cherokee Nation*. New York: St. Martin's Press, 1993.

Moulton, Gary E. *John Ross: Cherokee Chief*. Athens: University of Georgia Press, 1978.

Perdue, Theda. *Cherokee Women*. Lincoln: University of Nebraska Press, 1998.

Steele, Phillip W. *The Last Cherokee Warriors*. New York: Pelican Publishing Co., 1993.

Strickland, Rennard. *Fire and the Spirits: Cherokee Law from Clan to Court*. Norman: University of Oklahoma Press, 1975.

Wilkins, Thurman. *Cherokee Tragedy: The Ridge Family and the Decimation of a People*. 2nd ed., rev. Norman: University of Oklahoma Press, 1986.

Woodward, Steele Grace. *The Cherokees*. Norman: University of Oklahoma Press, 1963.

Index

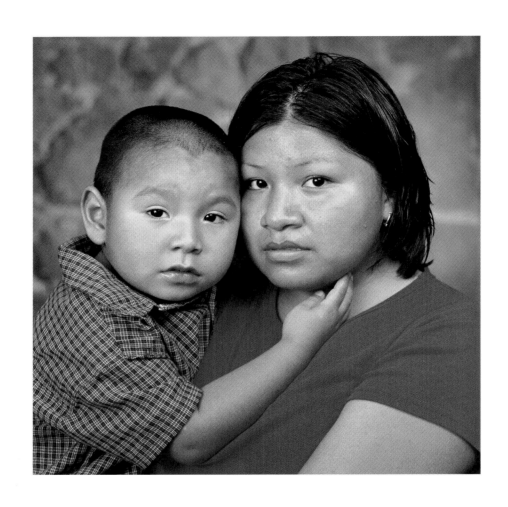

ᏣᎳᎩ